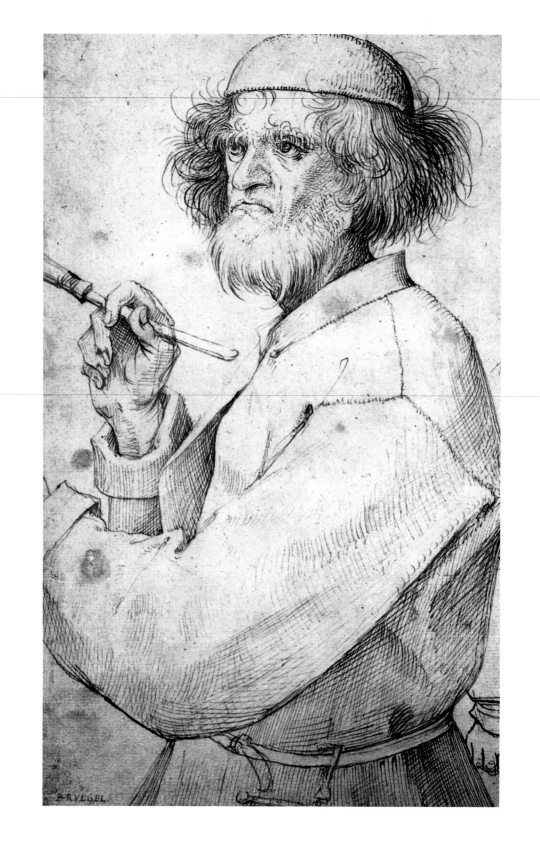

Rose-Marie and Rainer Hagen

PIETER BRUEGEL
the Elder
c. 1525–1569

Peasants, Fools and Demons

TASCHEN

KÖLN LONDON LOS ANGELES MADRID PARIS TOKYO

FRONT COVER:
The Peasant Wedding Banquet (detail), 1568
Oil on canvas, 114 x 164 cm
Vienna, Kunsthistorisches Museum Wien
Photo: AKG Berlin

ILLUSTRATION PAGE 1:
Summer (detail), 1568
Pen and Indian ink, 22 x 28.6 cm
Hamburg, Hamburger Kunsthalle

ILLUSTRATION PAGE 2 AND BACK COVER:
The Painter and the Connoisseur (detail), c. 1565–68
Pen and Indian ink, 25 x 21.6 cm
Vienna, Graphische Sammlung Albertina
Photo: AKG Berlin

To stay informed about upcoming TASCHEN titles,
please request our magazine at www.taschen.com or write to
TASCHEN America, 6671 Sunset Boulevard, Suite 1508,
USA–Los Angeles, CA 90028, Fax: +1-323-463 4442.
We will be happy to send you a free copy of our magazine
which is filled with information about all of our books.

© 2005 TASCHEN GmbH
Hohenzollernring 53, D–50672 Köln
www.taschen.com
Original edition: © 1994 Benedikt Taschen Verlag GmbH
Design by Barbro Garenfeld Büning, Cologne
Cover design by Catinka Keul, Angelika Taschen, Cologne
English translation by Michael Claridge, Bamberg

Printed in Singapore
ISBN 3–8228–5991–5

Contents

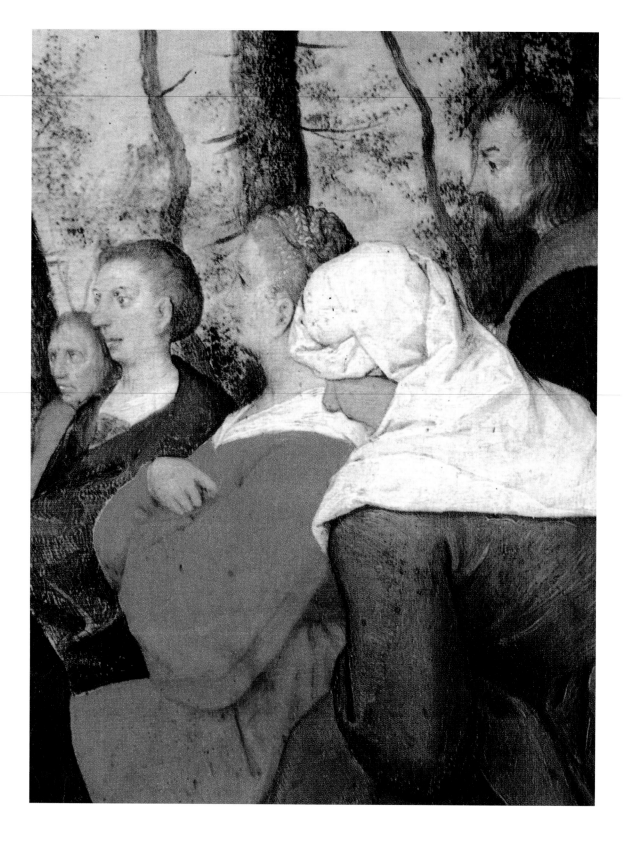

A Brief Life in Dangerous Times

Pieter Bruegel was about forty years old when the Duke of Alba entered Brussels. The painter was married, and had a son. His reputation as an artist was not as widespread across Europe as that of the recently deceased Michelangelo, nor again as that of Titian, by whom every prince sought to have his portrait painted. Many knew of Bruegel, however, and his works had a recognized cash value in his immediate home area, as can be deduced from the inclusion of sixteen Bruegels in the list of possessions which a Netherlands merchant gave as surety.

Bruegel was living in Brussels when Alba led his army into the city in August 1567. The Duke had been sent by Philip II, the Spanish king, to whose empire the Netherlands provinces belonged. The commander's orders were to forcibly convert the Protestants; during the years that followed, he would have several thousand Netherlanders sentenced to death. This extreme harshness resulted first in an uprising, and then in a war which was to last eighty years, ending with the division of the land into Catholic Belgium (as it would later become known) in the south and Protestant Holland in the north.

King Philip of Spain was a staunch Catholic: "I would rather sacrifice the lives of 100,000 people than let up in my persecution of the heretics."[1] He regarded Catholicism as the state religion; accordingly, heretics also constituted a political threat. In 1566, Netherlands Protestants – in particular Calvinists – had destroyed the religious images in Catholic churches, using spears and axes to pull statues of saints from their pedestals and tear altar paintings to pieces. For them, worshipping material images was nothing less than idolatry. What the Calvinists regarded as a struggle for the true faith amounted to rebellion in Philip's eyes, and he therefore despatched Alba as his commander, a man known – indeed, notorious – for his ruthlessness. 1567, the year in which he entered Brussels, would bring the great turning-point in the history of the Netherlands provinces; and Bruegel was to witness the events from close to.

We possess no clear written indications as to whether the painter supported the Protestant or the Catholic side in this struggle. Nor is it readily apparent what message his pictures convey: we must search for hints. In the year of the "breaking of the images", Bruegel painted *The Sermon of St. John the Baptist* (1566, ill. p. 8), of whom the Bible tells us that he had announced the appearance of Christ on earth. Bruegel has portrayed St. John preaching in the woods. We can make out a river, mountains, and a church in the background; some of the many listeners in the foreground are clad in striped garments, characterizing them as coming from the Middle East – yet the scenery and the clothing of the other figures point to a setting in the Netherlands of Bruegel's day.

It was nothing unusual at that time to place biblical events in a contemporary setting, in the painter's own surroundings; occasionally, however, religious motifs were also given political topicality. Such is the case here: non-Catholics were compelled to practise their religion in secret gatherings as long as the authorities for-

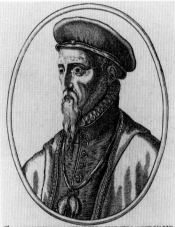

FERDINANDVS ALVARVSA TOLETO DVX D'ALVA

The Duke of Alba, anonymous engraving, 16th century
Alba (1507–1582), Spanish duke and military commander, was given the task of ridding the Netherlands of heretics. Bruegel's final years were lived out under the shadow cast by Alba's reign of terror.

ILLUSTRATION PAGE 6:
The Sermon of St. John the Baptist (detail), 1566
Unlike such painters as Albrecht Dürer, Pieter Bruegel produced no self-portraits, being disinclined to glorify his own person. Occasionally, however, one may find a bearded figure occupying an unassuming position at the edge of a picture, a figure who might possibly be the painter himself.

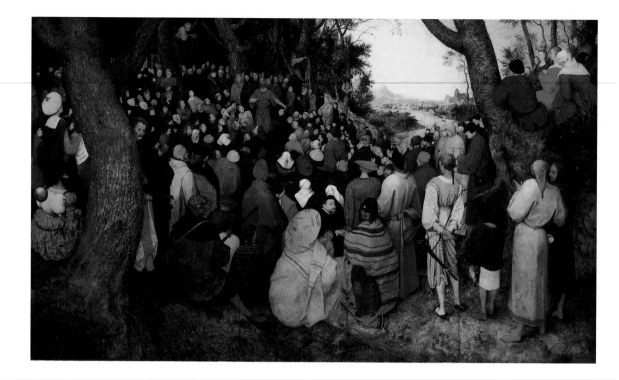

The Sermon of St. John the Baptist, 1566
Protestant preachers roamed the Netherlands, propagating their new teachings in the open air. The same was true of the Anabaptists, who based their religious teachings on those of St. John the Baptist. In depicting a contemporary gathering, Bruegel has put the biblical John the Baptist in the place of the preacher. His left arm is indicating Jesus, who clearly stands out among the crowd through his light-coloured garment. (Details pp. 6, 9)

bade them freedom of religion. This particularly affected the socially radical sect of the Anabaptists. Like St. John, who had baptized the adult Christ, they too practised adult baptism, meeting in the open air. A critical contemporary wrote of one such meeting in the woods: "… it was primarily the common folk one saw there, people with an immoral way of life… to be honest, however, one also came across people there who enjoyed good reputations and led blameless lives. One would never have believed that such people would go to these sermons."[2] Bruegel, too, has painted not only the "common folk". The bearded listener at the right-hand edge of the picture resembles the artist himself (ill. p. 6) – a furtive self-portrait? At any rate, he has left a memorial in the form of this picture to the secret religious meetings and their sermons.

We may suppose that two other paintings also contained sensitive political material. Both of them give particular emphasis to a black figure on horseback. The new ruler in the Netherlands was known as "Black" Alba on account of his clothing and cast of mind. Both paintings depict religious scenes: *The Conversion of Saul* (1567, ill. p. 11) and *The Massacre of the Innocents* at Bethlehem (c. 1566, ill. p. 12).

Bruegel has shifted the scene of the conversion into the mountains. Soldiers armed with spears are advancing upwards out of a valley; in the distance one can make out the sea. It is possible to distinguish, relatively small but in the middle of the picture, the figure of a rider who has fallen from his horse. According to the biblical account (Acts 9), the Roman officer Saul was on his way to Damascus to arrest Christians there. As he approached the city, a flash of light blazed around him and threw him to the ground. He heard a divine voice, was converted to Christianity, and took the name of Paul from that moment on. The light from heaven and the city are missing from Bruegel's work; instead, the painter has depicted the sea and the mountains. It was from the sea, from the Italian coast, that Alba and his soldiers came, their route thus necessitating a crossing of the Alps. A black figure sitting on a white horse and seen from the rear is placed in such a way that he must surely see

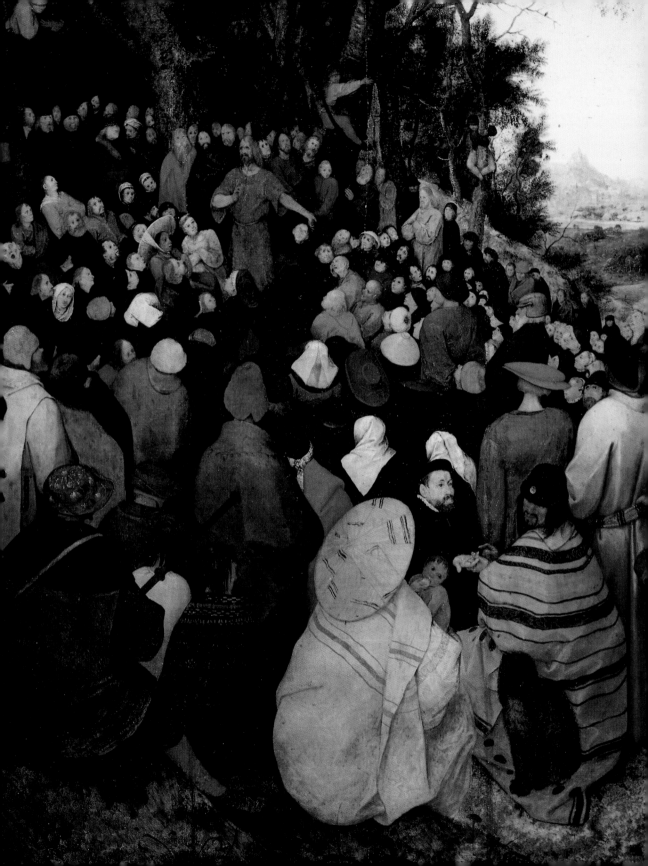

the fall of the other rider. One possible interpretation: the painter hopes that Alba, known as a ruthless persecutor of heretics, will be converted on his way to the Netherlands. The painting is dated 1567 – the year after the "breaking of the images", the year in which Alba and his army entered the Netherlands.

The second painting portrays the killing of all the little boys in Bethlehem, Christ's birthplace. Herod, governor of the Roman occupying power, had ordered the massacre of the children because he felt threatened by the unknown "newborn King of the Jews". Once again, Bruegel has set the biblical story in his own time and country. Soldiers are forcing their way into the houses of a snowbound village, tearing the children from the arms of their mothers – wintry stillness on the one hand, murder and manslaughter on the other. A menacing troop of riders in grey armour looks on, headed by an officer in black. Like Alba, he has a long white beard.

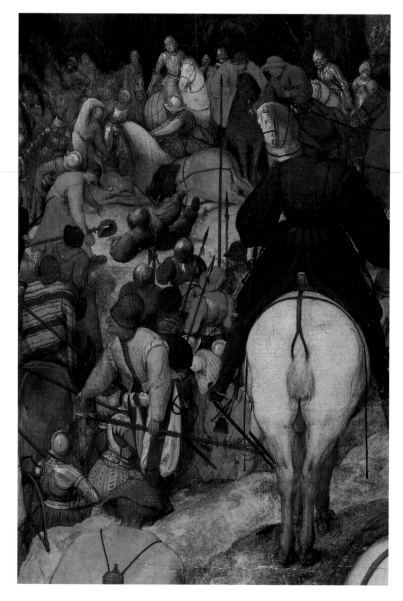

The Conversion of Saul (detail), 1567
Bruegel has given particular prominence to a black rider seen from the rear, who is observing the fallen Saul. The painter was presumably hoping that the reputedly terrible "Black" Alba would undergo conversion.

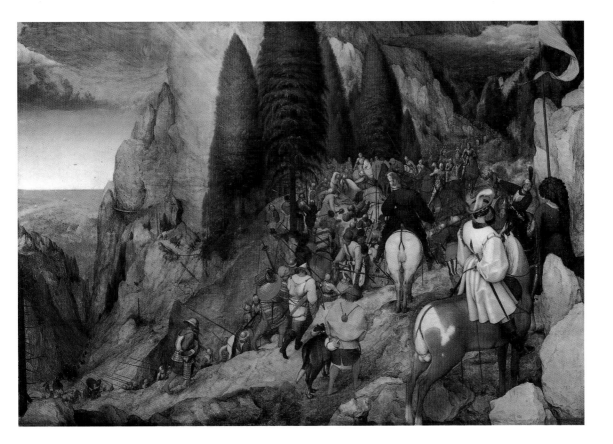

A rider with the Habsburg double eagle on his chest is standing a little way away from the troop; the villagers have turned to him, pleading with him. Philip was of the House of Habsburg; his half-sister, Margaret of Parma, formerly Regent of the Netherlands, had been stripped of power by Alba. It is conceivable that the observer is being asked to differentiate between the ruthless commander and the Habsburg Regent.

We do not know whether or to what extent Bruegel was actively involved in the resistance against Spanish Catholic rule. After all, Cardinal Granvelle, one of Philip II's advisors, also purchased works from him. However, the painter maintained a distanced, critical position; that much may be deduced from his circle of acquaintances and the first biography of Bruegel, which appeared in 1604. His biographer, Carel van Mander, tells us that, on his deathbed, Bruegel instructed his wife to burn certain drawings, since their captions "were all too biting and full of scorn..." The painter acted in this way, van Mander adds, "either because he regretted having done them or because he feared that they could have unpleasant consequences for his wife."[3]

Pieter Bruegel the Elder died on 5th September 1569, two years after Alba had entered Brussels and in the year in which the resistance of the Netherlanders turned to open rebellion. In January, according to official records, the Brussels city council had released him from his obligation to have Spanish soldiers billeted on him, "so that he may be enabled to continue his activities and his work in this city."[4] Were there Spaniards living in his studio? Did he need looking after because of some serious illness? An indication of prolonged sickness is the fact that no dated works survive from the last year of his life.

The Conversion of Saul, 1567
A biblical motif with political overtones. The painter has set Saul's conversion to Paul in a mountain landscape. The sea may be seen in the distance. It was from there, from the Italian coast, that the Spanish troops set off to cross the Alps, their task to drive out the heretics and crush Netherlands efforts to obtain more freedom. (Detail p. 10)

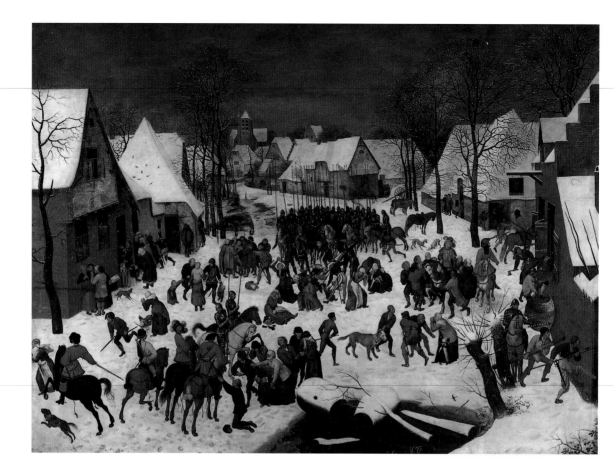

The Massacre of the Innocents, c. 1566
The Bible tells us that King Herod ordered the killing of all newborn boys in Bethlehem. Bruegel has placed the scene in a Netherlands village. A group of armoured horsemen are supervising the slaughter. It was one of the characteristics of Spanish troops that they held their lances in an absolutely upright position. The troop's leader, clad in black and with a long white beard, is presumably intended as a reference to the Duke of Alba. (Detail p. 13)

Van Mander comments with regard to one of Bruegel's last pictures, *The Magpie on the Gallows* (1568, ill. p. 82), that "he bequeathed his wife a picture with a magpie on a gallows. He was referring by the magpie to the gossips, whom he would like to see hanged."[5] It could be that gossips had harmed him to such an extent in his private life that he wished them dead. It is also possible, however, that Bruegel was thinking of informers, Alba's system of terror being based upon secret denunciations. The gallows also suggests political associations. The Spanish authorities had ordered in 1566 that "predicants" were to be hanged.[6] "Predicants" were preachers who spread Protestant doctrine, an activity punishable by death. In contrast to death by the sword or by fire, death on the gallows was regarded as dishonourable. This dispensation thus linked it to the Spanish Catholic rulers in a particularly bitter manner.

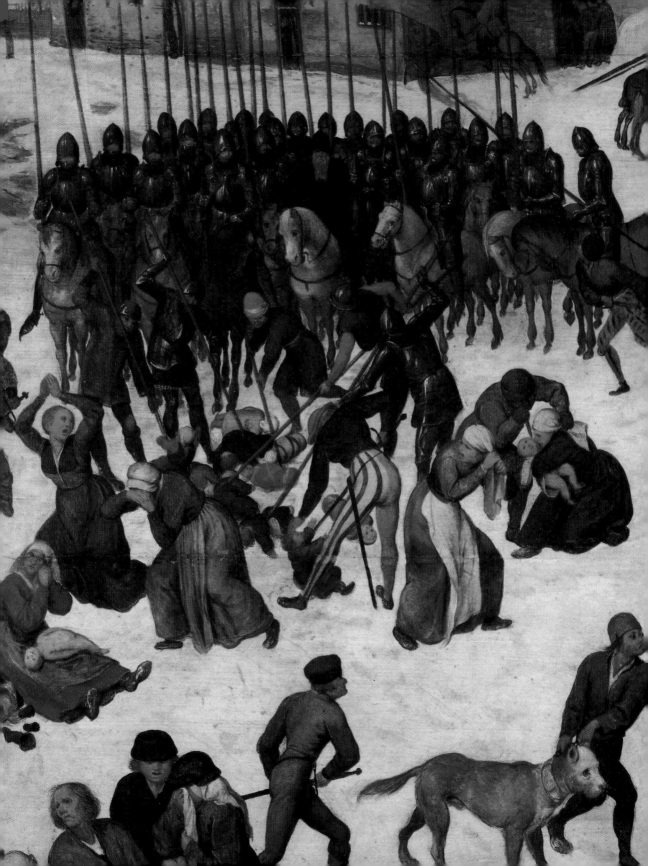

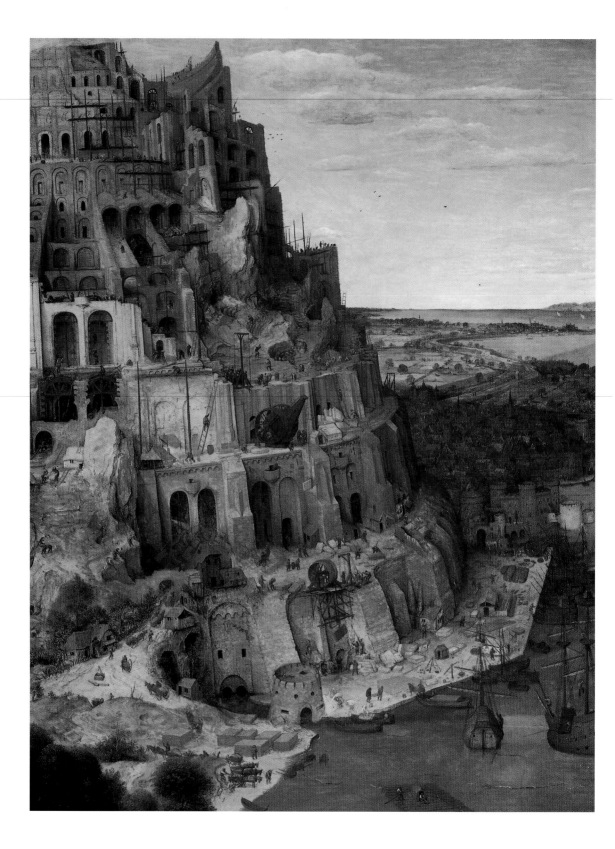

Antwerp: a Booming City

We know neither where nor precisely when Bruegel was born. There were no state birth registers, and church baptismal records were more the exception than the rule. The first written mention of "Peeter Brueghels" dates from 1551, when he was enrolled as a master in the Guild of St. Luke in Antwerp. New masters were usually between 21 and 26 years of age, so Bruegel could have been born between 1525 and 1530. To put this in perspective, it would be some fifty years before Rubens (1577) and some eighty years before Rembrandt (1606) were born.

Bruegel's birthplace is assumed to have been Breda or some nearby village with a name similar to that of the painter. He would settle down twice in especially wealthy cities, first in Antwerp and later in Brussels, the residence of the Habsburg Spanish regent.

Antwerp was the city with the highest growth rate in Europe, the new financial and economic centre of the western world, the focal point for businessmen from many countries. The discovery of the sea routes via Africa to Asia, and over the Atlantic to America, had helped Antwerp to a position of prominence, with the old trade routes via the Mediterranean losing and the ports along the Atlantic coast gaining in importance. Antwerp was also favourably situated for north-south traffic, involving such goods as silk and spices from the Middle East, grain from the Baltic countries, wool from England. Artists and craftsmen also profited from the turnover of goods and rapid financial transactions. It is believed that 360 painters were at work in Antwerp in 1560, an unusually high number. Given a population of some 89,000 inhabitants (the figure for 1569), this would work out at approximately one painter per 250 citizens. For many decades, there was no better place for painters to be north of the Alps than in Antwerp.

The painters' exceptionally high numbers also made them particularly crisis-prone, however. A temporary economic slump could have been the reason for Bruegel's journey to Italy in 1552. There are no written records of this journey, but we do have sketches, drawings and paintings which bear witness to its having taken place. Virtually every contemporary painter went travelling, visiting Venice, Florence, and Rome to learn from the pictures of the Italian masters and especially to study the works of antiquity. Many of these Netherlands painters, as "Romanists", brought Renaissance ideas and ideals back with them to the north. Bruegel was not one of them, however; he returned to Antwerp from Italy in 1554, to stay there until 1562.

The boom-town atmosphere of the rapidly growing city will have been frightening for many of its inhabitants. The people of the 16th century were accustomed to life in small, manageable communities in which the population was relatively stable and everyone knew everyone else. This was not the case in the metropolis of world trade. The population of Antwerp well-nigh doubled between 1500 and 1569. Some one thousand souls of this host were foreigners, speaking different languages and practising different customs; they were watched with suspicion. The loss of church

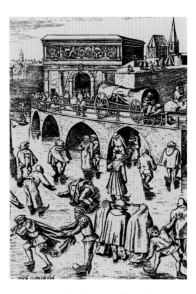

Skating outside St. George's Gate, Antwerp (detail), 1559
Antwerp was to develop in the 16th century from a small port to Europe's business metropolis. Artists also profited from the rapid financial transactions. Bruegel lived here from 1554 to 1563.

ILLUSTRATION PAGE 14:
The Tower of Babel (detail), 1563
Foreign merchants, new religious groupings, and the city's rapid growth led to problems of orientation and communication in Antwerp. An allegory for this situation was seen in the biblical account of the Tower of Babel: intended to reach up to heaven, it displeased God, who stripped humankind of their common language, thereby preventing the completion of the tower's construction.

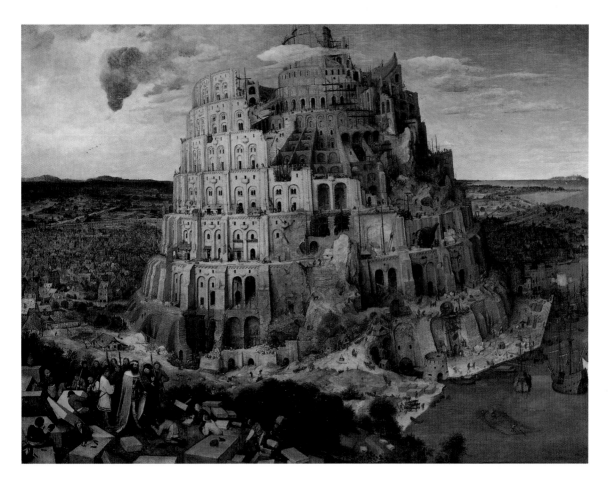

unity further contributed to the general insecurity and disquiet, with Catholics living next to Calvinists, Lutherans and Anabaptists. The result was a "multicultural" society with problems of communication, especially with respect to matters of religion.

Contemporaries saw a possible allegory for this unaccustomed situation in the biblical story of the Tower of Babel, as related in Genesis 11. King Nimrod had wanted to build a tower, the top of which would reach to heaven. God, regarding the construction as an act of arrogance, of hubris, had punished the people by stripping them of their common language. Having lost the ability to communicate with one other, the builders scattered, leaving the work unfinished.

Bruegel painted the Babylonian tower no less than three times. *The Tower of Babel* (1563, ill. p.17) and *The "Little" Tower of Babel* (c. 1563, ill. p.21) have survived; the former may be seen in Vienna, the latter in Rotterdam. A gigantic edifice has been depicted twice. Never before had a painter successfully rendered the dimensions of the tower so vividly, nor the extent to which it surpassed everything previously known to man.

Bruegel has portrayed the construction work in both paintings not as some distant event but rather as a contemporary building project, complete with a wealth of realistic details. The pictures are brought to life, for example through his selection of a riverside location for the building site: it was along waterways that bulk goods such as stones were customarily transported. Bruegel's depiction of lifting devices is almost pedantic. A powerful crane stands on one of the ramps in the

***The Tower of Babel**, 1563*
Bruegel has placed the building site in a coastal landscape; the Netherlanders acquired a considerable proportion of their wealth from maritime activities. The tower is also situated near a river, since it was along the waterways, and not via the unpaved country roads, that bulk goods were transported in those days. The painter has given the biblical account many realistic features, among them the city panorama. (Details pp. 14–19)

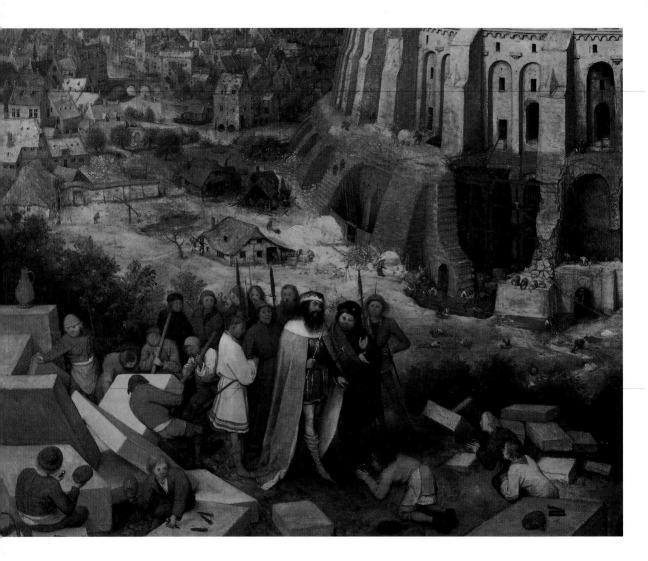

The Tower of Babel (details), 1563
King Nimrod is paying a visit to the building
site, stonemasons going down on their knees
before him. Performing the kowtow was not
common practice in Europe; Bruegel made
use of it to point to the story's oriental origins.
He remained true to his surroundings for most
of the other details, however: a treadwheel
crane of the type to be seen in the detail on
the right is believed to have stood in the Ant-
werp marketplace.

Vienna picture, with three men treading away in the front drum and a further three
– albeit invisible – in the rear one; such cranes were quite capable of raising stone
blocks weighing several tons. The painter will have been familiar with the pier but-
tresses from Gothic cathedrals, where they provided resistance to the side thrust of
the walls. He has put several huts on the ramps spiralling up to the top of the
tower; this, too, was in keeping with the reality of contemporary large-scale build-
ing projects, where each guild or construction team would have had its own on-
site hut.

In the Vienna picture, Bruegel has spread out a city at the foot of the edifice
towering up into the clouds. This is one of his rare urban landscapes. In the fore-
ground, King Nimrod is inspecting the work of the stonemasons, one of whom is
down on his knees before the monarch. In Europe, subjects went down before poten-
tates on only one knee; going down on both, the kowtow, is Bruegel's sole indica-
tion that the king in question here is from the Middle East.

Nimrod's presence in the picture from Vienna recalls the King's arrogance and
the motif of hubris. The King is absent in the darker, seemingly more threatening
painting in Rotterdam; instead, a procession with a red baldachin, scarcely visible to

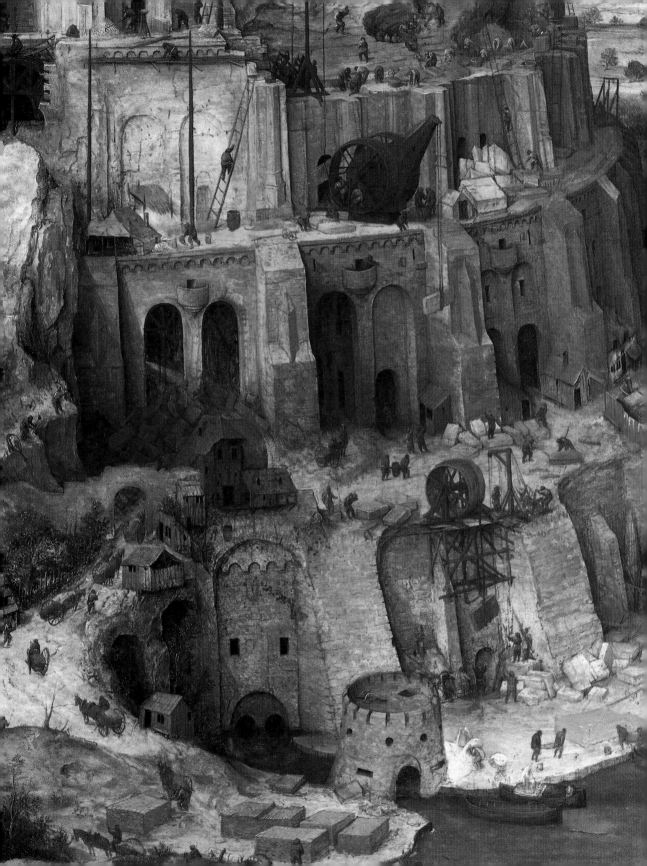

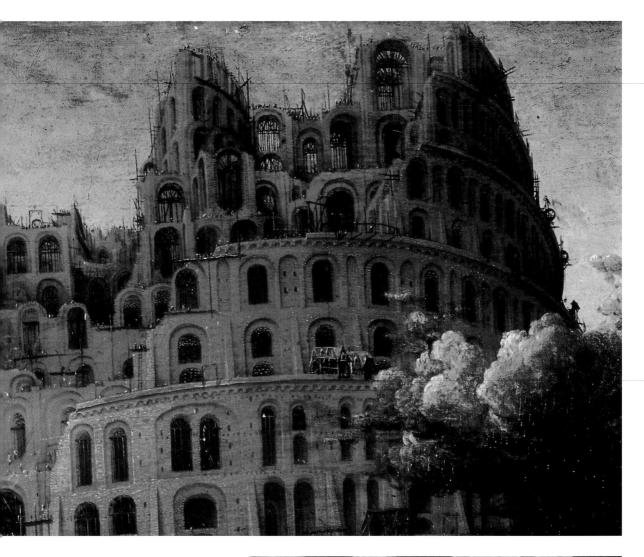

The "Little" Tower of Babel (details), c. 1563
The Christian tradition interprets the tower,
which was intended to reach up to heaven, as
a symbol of hubris, of arrogance. In the pic-
ture from Vienna, it is King Nimrod, and thus
the worldly potentate, who is the target of
criticism. Here, in the Rotterdam painting, an
almost invisible church procession is ascend-
ing the ramps: Bruegel is criticizing the Cath-
olic Church.

the naked eye, has been inserted on one of the ramps. It was customary for Catholic dignitaries to proceed under such baldachins – an indication that not even the higher ranks of the clergy are immune to arrogance? These dabs of colour must have been important for Bruegel, since he has placed them on the same level as the horizon line, at the very midpoint of the picture seen from the side.

A picture entitled *Babylonian Tower* also appears in the surety list of Nicolas Jonghelinck, the Antwerp merchant and financier; however, it is unknown to which version reference was being made. In 1565, Jonghelinck possessed sixteen paintings by Bruegel, and will presumably have been typical of the painter's circle of patrons – wealthy, educated, a member of the élite. Two paintings by Bruegel were also to be found in the possession of Cardinal Antoine Perrenot de Granvelle, one of Spain's most influential representatives in the Netherlands for several years and later a member of the Council of State in Madrid.[7]

We can only assume that many of Bruegel's paintings were commissioned by his patrons, albeit certainly without detailed instructions; in contrast, we may be certain that the majority of his drawings, which served as models for engravings, were executed to order. Bruegel's patron here was Hieronymus Cock, who had works engraved, printed and sold in his Antwerp art-shop, "The Four Winds". Cock will pres-

The "Little" Tower of Babel, c. 1563
Bruegel painted this subject at least three times; we still possess two of the works. The "Big" Tower hangs in Vienna, the "Little" Tower in Rotterdam. (Details p. 20)

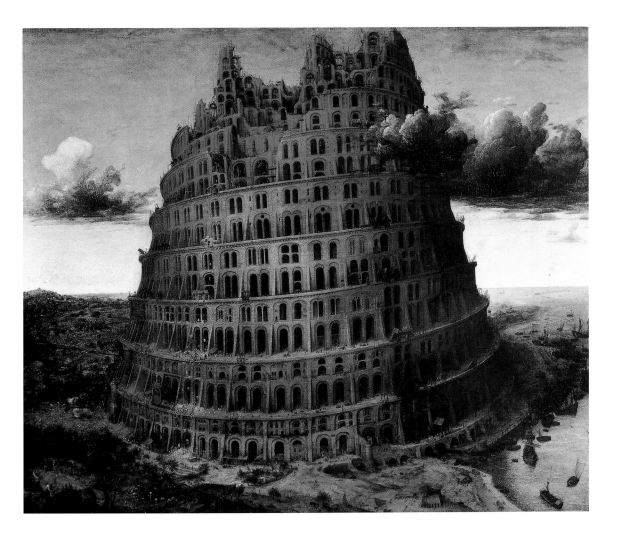

The Big Fish Eating the Little Fish, 1557
A faceless man is using an oversized knife to
slit open the belly of a fish, out of which are
slithering other fish which in turn have smal-
ler fish in their mouths. The caption – put into
the mouth of the man in the boat with his son
– surely referred not only to the fierce compe-
tition in Antwerp: "Look, my son, I've known
for a long time that the big fish devours the
little one."

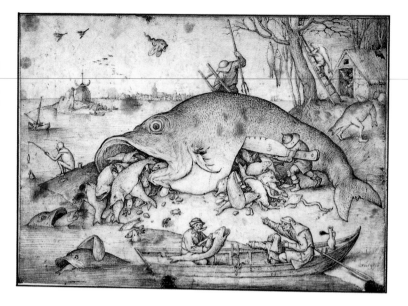

umably have set out in some detail what he expected. He wanted to serve the market,
to fulfil the wishes of his public, and if a picture was by an unknown artist, then he
would also occasionally falsify the name for the sake of better marketability, claim-
ing that the picture was the work of a popular artist. Such was Bruegel's experience
as a young man: it was he who drew *The Big Fish Eating the Little Fish* (1557, ill.
p. 22), yet the picture was engraved, printed and put on sale in the name of the
Netherlands painter Hieronymus Bosch, who had died in 1516, some ten years be-
fore the birth of Bruegel.

Such a deception was quite possible, since Bruegel had produced fantastic
figures identical in style to those of his late compatriot. Smaller fish are slithering
out of the mouth of a big fish lying on land, themselves giving forth even smaller
ones. The big fish is being slit open by a human figure with an enormous knife, on
the blade of which the imperial orb is engraved: emperors and kings live at the ex-
pense of their subjects just as the more powerful merchants in Antwerp live at the
expense of their weaker brethren – the big eat the little. It is a terrible world, one
ruled by inhuman, diabolical greed, which the father in his boat is showing his son,
and Cock his clients in the markets in Antwerp and the surrounding area.

Only once in Bruegel's paintings do we see how this world, the city of Antwerp,
actually looked, and that solely in passing, as the background to *Two Monkeys*
(1562, ill. p. 23). This puzzling picture is unusually small, measuring a mere 20 x 23
cm. The animals appear to be squatting in the vaulted window of a fortress; they are
chained, and nutshells are strewn about. Bruegel could have been thinking of the
Netherlands proverb "to go to court for the sake of a hazelnut", in which case the
monkeys would have lost their lawsuit and their freedom for the sake of something
as unimportant as the kernel of a nut. The work may also reflect the oppressive at-
mosphere under Spanish rule, or could be seen in connection with Bruegel's depar-
ture from Antwerp.

Given the total absence of knowledge regarding the circumstances that prompted
this picture, however, the observer would be advised to place all speculation on one
side – indeed, as we should usually do – and simply see what the painting is saying
to him: the dejection of the creatures, and the temptingly beautiful urban panorama,
unattainable for those imprisoned in massive fortress walls.

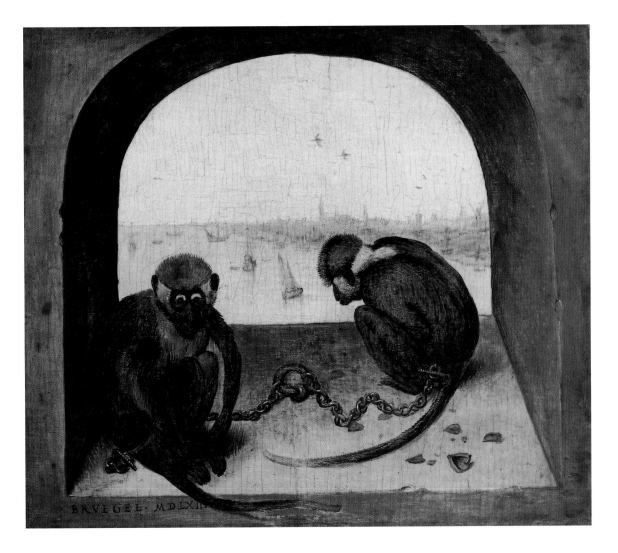

Two Monkeys, 1562

The significance of the two monkeys, chained and squatting dejectedly, is unclear. In Christian iconography, monkeys generally represented stupidity or such vices as vanity or miserliness. The nutshells refer to a Netherlands proverb, "to go to court for the sake of a hazelnut". This would suggest that the monkeys had risked their freedom for something unimportant. In the background, we see a view of Antwerp from the sea. Bruegel left Antwerp in 1563 to settle in Brussels.

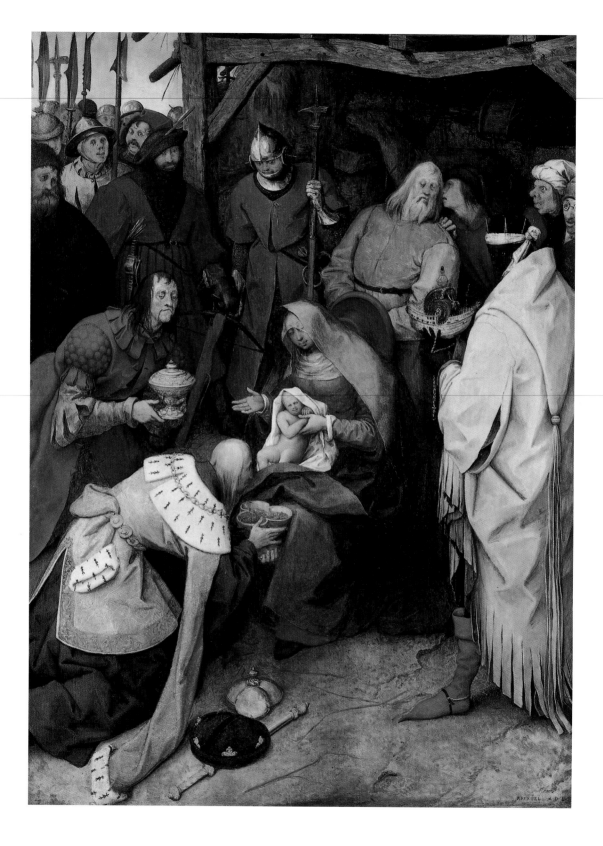

The Holy Family in the Snow

For centuries past, churches and monasteries had been among the most important clients commissioning art. The Reformation put an end to this tradition, the Protestants considering the rich pictorial ornamentation of Catholic buildings to be symptoms of secularization, or even of a forbidden display of magnificence and power. Theological objections were also raised, albeit not by Luther but by Calvin. Maintaining that "every pictorial representation of God contradicts His nature", he stated that "it is sinful to give God visible form; to create graven images is to completely break away from the true God."[8]

Bruegel worked with others on an altar in his early years, in 1550/51; we know this from documents, although the altar itself is lost. As far as can be ascertained, not one of his paintings was executed for a church. One reason for this may be seen in the political and religious situation at the time, Lutheran and Reformed Church communities being uninterested in such works and Catholics holding back – in those cases where they had actually been able to keep their buildings. Another reason was Bruegel's style, which was such as to exclude him from consideration by Catholics. The strategy of the Counter-Reformation, as formulated at the Council of Trent in 1545–63, required artists to portray saints in a way which emphasized their sainthood and clearly distinguished them from other mortals. Bruegel did the very opposite.

This is even true of a work which at first appears to correspond to Catholic requirements: *The Adoration of the Kings* (1564, ill. p. 24). Mary is depicted sitting in the centre of the picture, holding the Christ child on her lap. Her face is as beautiful as that of a young girl, quite capable of fulfilling the traditional Madonna ideal. One of her eyes is hidden, however; her posture is bowed; and the Christ child seems to be pulling back in fear. Furthermore, the face of the left-hand king – one of the saints after all – has very earthly features, while the brightly coloured robe of the right-hand king renders its wearer more prominent than Mary. The final straw – in the eyes of Counter-Reformation severity – is the depiction of Joseph: instead of giving himself over completely to the holy event, he is leaning towards an unknown person so that the latter may whisper something in his ear. One could reply that it is precisely through this act of whispering that respect is shown the Adoration. It is too human an act, however; it distracts the observer, and would undoubtedly have fallen victim to the religious censorship of art.

Bruegel painted the Adoration of the Christ child by the Three Kings or Magi three times; none of the works reveals the splendour and idealization considered appropriate in Catholic circles. The earliest painting, *The Adoration of the Kings* (between 1556 and 1562, ill. p. 29, top), which is in a poor state of preservation, is characterized by a large crowd of Netherlands and Middle Eastern people, the last, *The Adoration of the Kings in the Snow* (1567, ill. p. 29, bottom), by a natural event, namely by falling snow. This last version is also the boldest, the religious scene almost disappearing, integrated like some everyday occurrence into the life of a wintertime village.

Christ in Limbo (detail), c. 1562
It was not the belief in Jesus Christ that Bruegel was criticizing in his pictures, but rather the Catholic Church.

ILLUSTRATION PAGE 24:
The Adoration of the Kings, 1564
Bruegel depicts the Adoration as it could have been staged in a Passion play. It was admissible within the context of such plays that someone whisper something in Joseph's ear – not, however, in the case of pictures, according to the guidelines laid down by the Counter-Reformation.

Bruegel's approach in *The Procession to Calvary* (1564, ill. p. 26) is similar: while Christ, who has collapsed under the cross, is located roughly at the centre of the painted wood panel, he is engulfed by the crowds pouring out of town on the left and riding or strolling in a great arc towards the hill of Calvary. It is the panorama of a day out. Riders in red coats – presumably a sort of constabulary – point the way. On the left near the road, some women with barrows and burdens are working against the flow of people. A grim-faced woman is holding back her husband – believed to be Simon of Cyrene, whom the soldiers are ordering to assist in carrying the cross. They must be making quite a commotion, for many bystanders are turning to look. It is not clear whether assistance in carrying the cross is in fact permitted. Whereas some of the accompanying executioners or craftsmen are indeed doing so, one of their number has placed his foot demonstratively on the cross, and the red-coats are also becoming involved. Boys are playing; a pedlar is sitting in the foreground, his back to the observer; once again we notice a man standing at the right-hand edge of the painting who bears a resemblance to the painter.

Most of the people in this general outing seem unaware of the significance behind the impending crucifixion. Only one group, on a raised rock in the right-hand foreground, does not fit into the general picture, on account of their old-fashioned Gothic garments and gestures of grief. Bruegel has collected together here the traditional women as if under the cross; John the disciple is comforting them. Why the artist should have added a different stylistic level to a picture otherwise

The Procession to Calvary, 1564
Bruegel has hidden Christ, who has collapsed under his cross, in the midst of a crowd moving towards the place of execution as if to a public spectacle, playing and horsing around, discussing. In the background, we can make out a Flemish Jerusalem on the left and the hill of Calvary on the right, with a rock and windmill of unknown significance between them. (Details p. 27)

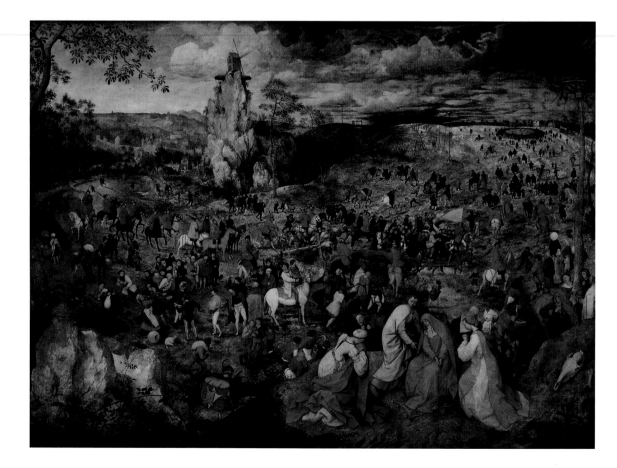

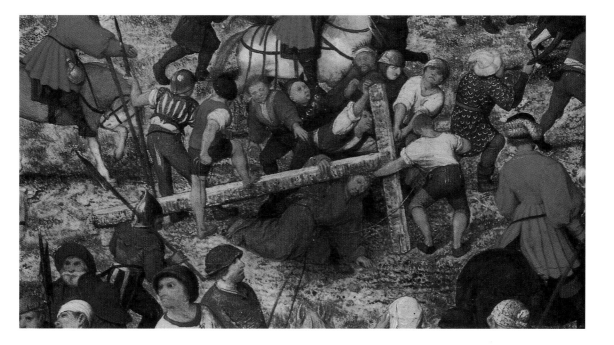

so realistic in detail remains unexplained. Though Bruegel was not the only artist to treat biblical scenes in an almost peripheral manner, his approach was probably the most consistent of those who painted in this manner. What was his intention here? We may be certain that he was not seeking to provoke; he did not want to be seen as degrading the fundamental elements of Christian belief. This is indicated by the fact that well-nigh half his paintings are devoted to biblical subjects, or at least include them.

Criticism of the Catholic Church may have played a part here – directed not against the faith but against the institution, the clergy and their worldly power. This criticism is also apparent in the artist's selection of subjects. Bruegel painted no martyrs, no saints from the history of the Catholic Church, but only biblical figures – those, in other words, who were of significance for every Christian. It is possible that anti-Spanish feelings were also at work here. The Catholic Church was so inextricably linked with the worldly rule of Philip that to attack the Church was to attack the King. Bruegel filled the area of which the saints were deprived with the people and scenery of the Netherlands. Intentionally or not, Bruegel's pictures reflect the wish that the foreign rulers be deposed, and therefore reveal something of the process of emancipation taking place in the Netherlands provinces.

This is but one aspect among many. The fact that the painter's work should not be viewed from this angle alone is illustrated by two grisailles, *The Death of the Virgin* (c. 1564, ill. p. 28, bottom) and *Christ and the Woman Taken in Adultery* (1565, ill. p. 28, top). Each of the panels is restricted to its religious subject-matter. In the former, St. John, next to the fireplace, appears to be asleep. In his dream, he sees the dying Virgin, with the believers from all over the world streaming towards her. In the latter picture, Jesus is writing with His finger in the dust the famous sentence concerning the stone which should be thrown at the woman taken in adultery by "he that is without sin amongst you" (John 8:7). The two paintings are very singular. The absence of different colours – grisaille – is compensated for by almost supernatural lighting effects, similar to those which Rembrandt would employ again and again in the following century.

The Procession to Calvary (details), 1564
The officers seem to be arguing as to whether Jesus should be helped in carrying his cross. At the right-hand edge of the picture we once again observe a bearded figure, perhaps that of the painter himself.

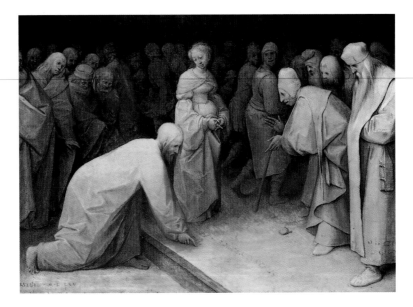

Christ and the Woman Taken in Adultery, 1565
The woman whom the Pharisees have accused has been portrayed by
Bruegel as a graceful figure in the centre of the picture. She represents
one of the few female figures to be painted by Bruegel not as an earthy
country woman but instead in accordance with the urban ideal of beauty.

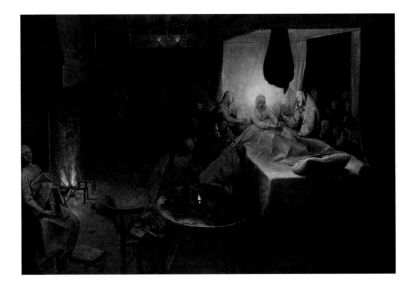

The Death of the Virgin, c. 1564
John the disciple, sleeping next to the fireplace on the left of the picture,
is dreaming that the apostles and other saints have assembled around the
bed of the dying Virgin. Bruegel is employing seemingly supernatural
lighting effects here, such as would later be typical of Rembrandt's work.

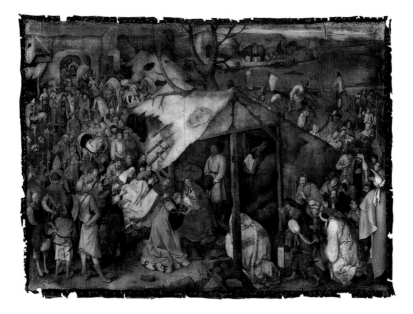

The Adoration of the Kings, between 1556 and 1562
Unlike the other two depictions of the Adoration, this work was painted
not on wood but on canvas, and is in poor condition. It is the earliest of
the surviving Adorations. Bruegel has surrounded the central event with a
large crowd of people, dressed partly in Netherlands dress, partly in
oriental fashion.

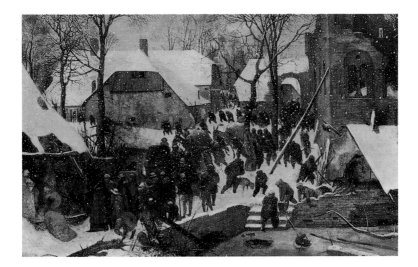

The Adoration of the Kings in the Snow, 1567
Bruegel has shifted the Adoration from the centre to the left-hand edge of
the picture, depicting it rather indistinctly behind a curtain of snow. The
work is characterized not by the religious motif but by a natural event and
the life of the people in a village in wintertime. It is possible that we have
here the first painting in the history of European art to depict falling snow.

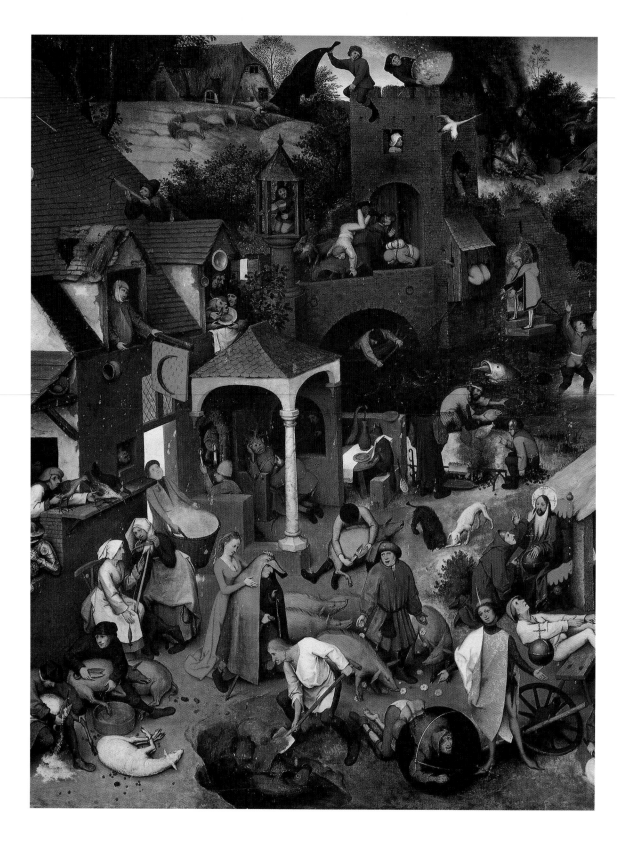

Exploring the World

Mediaeval paintings primarily depicted biblical figures, the saints, Heaven and Hell. Such works, most of them in churches and monasteries, were meant to show the faithful what they could not see with their own eyes. They thus served a devotional and didactic purpose.

In the Renaissance (which began in Italy some 100 years before Bruegel's birth), the focus of attention turned to man. The mediaeval concept of Earth, as a vale of tears filled with wretched sinners, faded. The status of man was enhanced; painters showed that he possessed a body, and placed him – with the aid of perspective – in a three-dimensional earthly environment. Reality was studied not only by the artists but also – even more so – by empirical scientists. The first circumnavigation of the world, undertaken by Magellan, had proved in 1521 that the Earth was round; in 1548, Pierre Coudenberg had laid out a Botanical Gardens in Brussels for the purpose of studying exotic plants, one of many such study gardens in this century; in 1560, the Church lifted its ban on the dissection of corpses, releasing the human body for examination; and in 1570, Abraham Ortelius published the first atlas of the world.

The Antwerp geographer Ortelius was a friend of Bruegel. Thanks to this man and others, the painter was familiar with the exploratory enthusiasm of his century. He too explored, after his own manner, presenting in his works areas of life previously neglected or even held in contempt. One rather peculiar example of this is the picture *Children's Games* (1560, ill. p. 32).

The subject of childhood had hitherto been virtually ignored in western painting and thought. Childhood was not viewed as a phase of life with any requirements of its own, but merely as the preliminary stage to adulthood. Children were treated as little adults, as the clothing portrayed in Bruegel's picture indicates: the girls' aprons and bonnets resembled those of their mothers, while the boys' trousers, jerkins and jackets echoed those worn by their fathers. Moreover, there were hardly any toys: only tops, hobby-horses, dolls, and windmills on long sticks. Most of Bruegel's children are managing without toys or making do with pigs' bladders, knucklebones, caps, barrels, hoops – such things, in other words, as could be found simply lying about.

Emotional affection was probably slight in comparison with that exhibited by parents and relations in the nuclear families of today. It was simply a matter of too many children being born, and too many dying in early childhood. Something of this lack of interest, this absence of any deep feeling, is conveyed in Bruegel's picture. The childlike element is stressed neither in the faces nor in the physique of the children. Some of them seem dull and rather stupid, all of them ageless. There is no trace of the idealizing manner with which children would be portrayed in the pictures of the centuries to come.

Bruegel has depicted more than 250 children here. Such a catalogue of games, such an enumeration of children's methods for exercising the body and preparing for the adult world through imitation, is without parallel in the history of art.

Warship Seen Half from Left, undated
The Netherlanders possessed one of the largest merchant fleets, and mercantile initiative led to the reconnaissance of distant lands. Bruegel took great pains with his technically exact depictions of ships.

ILLUSTRATION PAGE 30:
Netherlandish Proverbs (detail), 1559
The collecting of proverbs was one of the many encyclopaedic undertakings in the 16th century. Bruegel is offering more than a simple catalogue here: he presents us with a topsy-turvy world, with the Devil seen in the centre of the picture hearing someone's confession (cf. pp. 35–37).

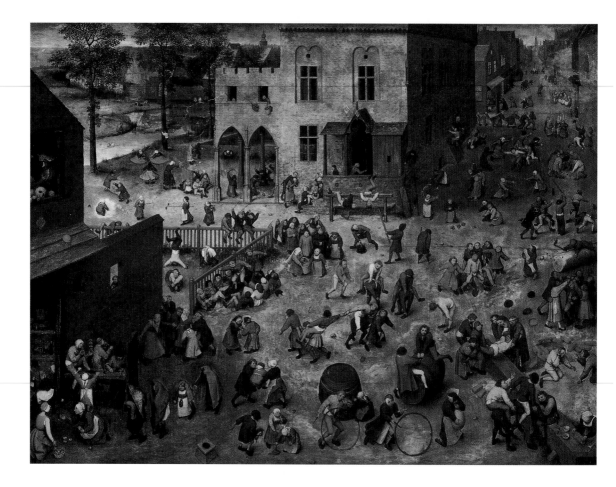

TOP:

Children's Games, 1560

Bruegel has portrayed over 250 children on
this panel. They are playing with pieces of
wood, with bones, with hoops and barrels –
specially crafted toys were rare in the 16th
century. Their faces often appear ageless: per-
haps the painter wished to warn the observer
against frittering away his life as if it were a
childlike game. (Detail right)

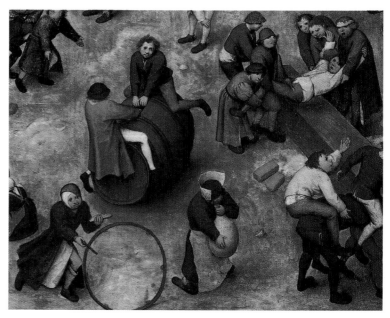

This picture can, however, be seen differently: not as a folkloristic inventory, but as a warning to adults not to fritter their life away as if it were a childlike game. One factor supporting this second interpretation is the absence of childlike elements in the faces of most of the children. The two interpretations are not mutually exclusive, however. If this picture is of interest for us today, then it is not because of its possible moral or innovative technique, but Bruegel's skilled mastery of colour and form. The work fascinates, yet it also disturbs, for reasons both of content and of form. There is no ideal vantage point from which the picture should be viewed, for example. The observer is required simultaneously to come close up to the work and to remain at a certain remove from it: only at a distance can he maintain the necessary overall view, yet only in close-up do the many little activities, figures and faces really come to life. The perspective causes additional problems; we customarily take up a position in front of the centre of a picture, assuming that the painter is showing us his world from this position. Bruegel does not. To follow the perspective, one would have to adopt a position in front of the right-hand half of the painting. Here the walls of the building meet in an equiangular manner in the long street, the painter drawing the observer's gaze upwards. Although the perspective leads the eye to the right, the picture does not "tip over". The edge of the houses leads diagonally down towards the left and forwards. The buildings at the left-hand edge of the picture, their dark mass making them especially prominent, create a balance, and also a relationship between foreground and background that is charged with tension. Bruegel places his children play in a

The Ass in the School, 1556
The population of the Netherlands provinces had a high level of education – indeed, an Italian traveller even ventured the opinion that everyone could read and write. Bruegel is laughing at his countrymen's eagerness to learn: the caption comments that "An ass will never become a horse, even if he goes to school."

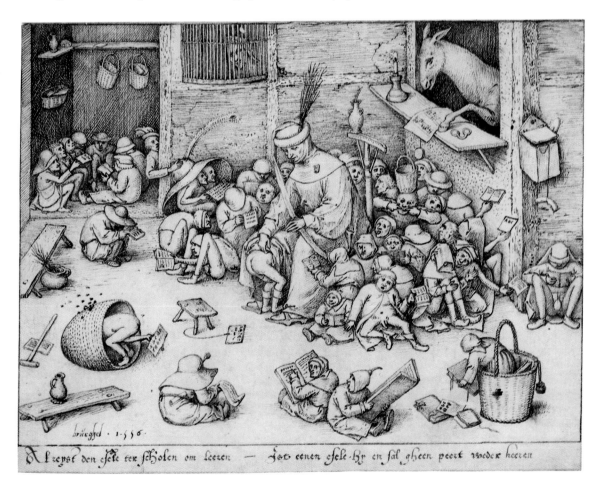

Twelve Proverbs, 1558
These panels, joined together to create one
picture, perhaps served originally as a kind of
plate. The majority of the proverbs may also
be found in the painting from 1559.

complex space; he fascinates us through artistic means, without our being immedi-
ately aware of what holds us for so long in front of this picture.

The same is true of *Netherlandish Proverbs* (1559, ill. p. 35). Here, too, the main
axis leads from front left to back right; here, too, Bruegel has built in a divergence
from perspective, in the form of the tarts on the roof, unexpectedly depicted head-
on rather than foreshortened. Given the well-thought-out manner in which Bruegel
painted, this can hardly be an error. Is he playing a game? Or is he consciously seek-
ing to confuse?

Collecting proverbs was one of the many encyclopaedic undertakings in the 16th
century. Erasmus of Rotterdam, the great humanist, began by publishing proverbs
and the famous formulations of Latin authors in 1500. Flemish and German collec-
tions followed, while Rabelais' novel *Pantagruel*, with its description of an island
of proverbs, appeared in 1564. By 1558, Bruegel had already painted his series of
Twelve Proverbs (ill. p. 34), consisting of small, individual panels. His village of
proverbs, however, was something apparently never attempted before; not a set of
proverbs somehow strung together but a painting completely worked out in every
detail.

More than a hundred proverbs and idiomatic expressions have been identified,
many no longer in current usage – and many reflecting the considerably more direct
language customary in that day and age! The majority describe stupid, immoral,
crazy ways of behaviour. A devil is hearing confession in the pavilion that forms the
focal point of the work; further to the right, a monk is mocking Christ and masking
him with a beard; to his left, a woman is hanging a blue cloak over her husband's
shoulders, signifying that she is deceiving him; a globe is hanging in front of the
wall of the house, its cross pointed downwards to indicate the "topsy-turvy world"
with which the painter was concerned: as with the children's games, he was motiv-
ated here not only by a passion for collecting but also by a particular, sceptical view
of his contemporaries.

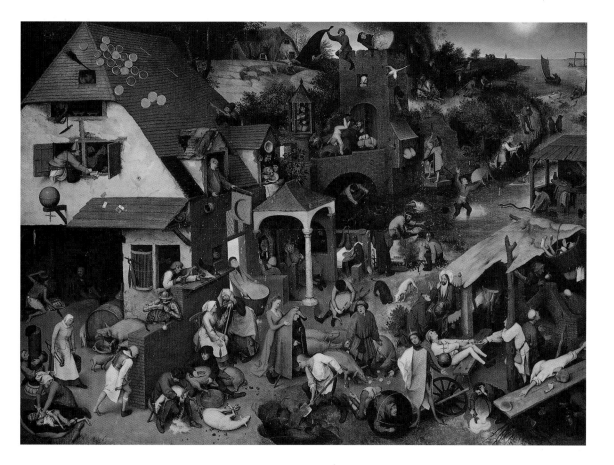

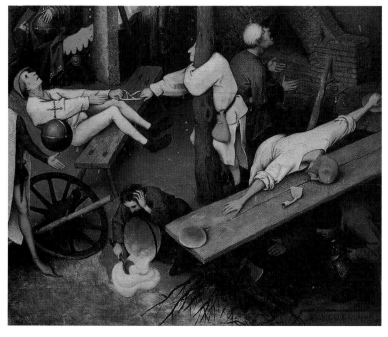

TOP:

Netherlandish Proverbs, 1559
More than a hundred proverbs and idiomatic
expressions have been identified (cf. pp. 36–
37), describing "topsy-turvy" ways of behavi-
our. This explains the other name occasionally
given the painting, that of *The Topsy-Turvy
World*. While one fellow lets the world dance
upon his thumb (to his tune), another is un-
able to stretch from one loaf of bread to an-
other – in other words, he is no good with
money. If you spill your porridge, you will
never be able to spoon it all back into the
bowl; if you try to open your mouth wider
than an oven door, you are overestimating
your abilities. (Details bottom and p. 30)

Netherlandish Proverbs

1 There the roof is tiled with tarts (a land of plenty; a fool's paradise; "Land of Cockaigne").

2 To marry over the broomstick (to go through a quasi-marriage ceremony; to live in sin under one roof is convenient but shameful).

3 To stick out the broom (the masters are not at home; "When the cat's away, the mice will play").

4 He looks through his fingers (he can afford to be indulgent because he is sure of his profit).

5 There hangs the knife (a challenge).

6 There stand the wooden shoes (to wait in vain).

7 They lead each other by the nose (they are tricking each other).

8 The die is cast (it is decided).

9 Fools get the best cards

10 It depends on the fall of the cards.

11 He shits on the world (he despises the world).

12 The world upside down (the opposite of the way things should be; "It's a topsy-turvy world").

13 To pull something through the eye (the hole in the handle) of a pair of scissors (to make a dishonest profit); or: an eye for an eye.

14 Leave at least one egg in the nest (to keep a "nest egg"; "Save something for a rainy day").

15 He has toothache behind his ears (possibly: to fool others by malingering).

16 a) He is pissing against the moon (to try to do the impossible; "To bark against the moon" or "To piss against the wind").

b) He has pissed against the moon (his enterprise has failed).

17 There is a hole in his roof.

18 An old roof needs a lot of patching up.

19 The roof has laths (there are eavesdroppers).

20 There hangs the pot (in the topsy-turvy world the chamber pot instead of the jug serves as an inn sign).

21 To shave the fool without lather (to make a fool of someone; "To take someone for a ride").

22 It is growing out of the window (it cannot be kept secret; "Truth will out").

23 Two fools under one hood ("Folly loves company").

24 a) To shoot a second bolt to find the first (foolish, misdirected perseverance).

b) To shoot all one's bolts (to use all one's ammunition at once is unwise because there is none left when really needed).

25 She can even tie the Devil to a pillow (spiteful obstinacy overpowers even the Devil himself).

26 He is a pillar-biter (a religious hypocrite).

27 She carries fire in one hand and water in the other (she is two-faced and deceitful).

28 a) To fry the whole herring for the sake of the roe ("To throw a sprat to catch a herring", that is, to sacrifice a trifle to gain something substantial).

b) His herring does not fry here (things are not going according to plan).

c) To get the lid on the head (to have to make pay for the damages; "To be left holding the bag").

29 a) He has more in him than an empty herring (many things often have a deeper significance than superficial observation would suggest; "There is more to it than meets the eye").

b) The herring hangs by its own gills (everyone must bear the consequences of his own mistakes).

30 To sit between two stools in the ashes (to miss an opportunity; to fail due to indecisiveness; "To fall between two stools").

31 What can smoke do to iron? (It is useless to try to change the existing order).

32 The spindle falls into the ashes (the business at hand has failed).

33 To find the dog in the pot. When one lets in the dog, it will get into the larder (pot) (to have one's trouble for nothing; to come too late to prevent loss or damage).

34 Here the sow pulls out the bung (poor management; negligence will be punished).

35 He runs his head against a stone wall (to pursue the impossible recklessly and impetuously).

36 To be driven into armour (to be enraged, angered; "To be up in arms over something").

37 To bell the cat (When one plans something which everyone finds out about, one's undertaking will turn out badly).

38 Armed to the teeth.

39 An iron-biter (a big mouth).

40 The hen-feeler ("To count one's chickens before they are hatched").

41 He always gnaws on one bone (endless, futile chore; or, to continually repeat everything; "To be always harping on the same string").

42 There the scissors hang out (symbol of pickpocketing; a place of cheating and fleecing: "a clip joint").

43 He speaks with two mouths (two-faced, deceitful; "To speak out of both sides of one's mouth").

44 One shears sheep, the other pigs (one has the advantage, the other the disadvantage; or, one lives in luxury, the other in need; "rich man, poor man").

45 Great cry and little wool ("Much ado about nothing").

46 Shear them but do not skin them (do not pursue your advantage at any price).

47 Patient as a lamb.

48 a) One winds on the distaff what the other spins (to spread malicious gossip).

b) Watch out that a black dog does not come in between (things could go wrong; or, where two women are together, always keep their own advantage in mind; the deceiver deceived).

49 He carries the day out in baskets (he wastes his time; "To set forth the sun with a candle").

50 To hold a candle to the Devil (to make friends in all quarters and to flatter everyone; to ingratiate oneself indiscriminately).

51 He confesses to the Devil (to give away secrets to one's enemy).

52 An ear-blower (a tattle-tale or gossip; "To fan rumours").

53 The fox and the crane entertain each other (Bruegel uses a motif familiar from Aesop's *Fables*: two deceivers always keep their own advantage in mind; the deceiver deceived).

54 What is the good of a beautiful plate when there is nothing on it? ("Gold plate does not fill your belly").

55 He is a skimming ladle or an egg-beater (a sponger, a parasite).

56 To chalk it up (it will not be forgotten; the debt must be repaid; "To be in a person's book").

57 He fills the well after the calf has drowned (measure taken only when an accident has occurred).

58 He has the world spinning on his thumb (everyone dances to his tune; "He has got the world on a string").

59 To put a spoke in someone's wheel (to put an obstacle in the way).

60 He has to stoop if he wants to get on in the world (whoever is ambitious must be devious and unscrupulous).

61 He ties a flaxen beard to the face of Christ (deceit often masquerades under the guise of piety).

62 To cast roses (pearls) before swine (Matthew 7:6; effort wasted on the unworthy).

63 She puts the blue mantle on her husband (she deceives him; "To place horns on his head").

64 The pig is stabbed through the belly (a foregone conclusion; it is irrevocable; "Things done cannot be undone").

65 Two dogs over one bone seldom agree (to quarrel bitterly over one and the same thing; "a bone of contention"; image of cupidity and jealousy; envy).

66 To sit on hot coals (to be anxious and impatient; "To be on needles and pins").

67 a) The meat on the spit must be basted.

b) It is healthy to piss on the fire.

c) His fire is pissed out (his fire has been extinguished; he is completely discouraged).

68 There is no turning a spit with him (he is uncooperative).

69 a) He catches fish with his bare hands (this shrewd fellow profits from the work of others by taking fish out of the nets which they have cast).

b) To throw a smelt to catch a cod (same meaning as 28a).

70 He falls through the basket (rejected suitor; to be turned down flat; to fail).

71 He is suspended between heaven and earth (he has got himself into an awkward situation and does not know what he should do).

72 She takes the hen's egg and lets the goose egg go (to make a bad choice as a result of one's greediness).

73 He yawns against the oven; or, he who is determined to out-yawn the oven will have to yawn for a long time (he tries to open his mouth wider than an oven door, that is, he overestimates his ability; "He bites off more than he can chew"; or, it is futile to set oneself up against those who are stronger).

74 He can barely reach from one loaf to the other (he cannot live within his budget).

75 a) He is looking for the hatchet (he is trying to find an excuse).

b) Here he is with his lantern (finally he has an opportunity to let his light shine – to show how smart he his).

76 A hatchet with a handle (the whole thing? – the meaning is unclear).

77 A hoe without a handle (something useless? – of unclear meaning; the object is a dough-scraper).

78 He who has spilt his porridge cannot scrape it all up again (once damage is done, it cannot be completely undone; "It is no use crying over spilt milk").

79 They pull to get the longest end (a tug-of-war; everyone seeks his own advantage).

80 He hangs on tightly; rather: Love is on the side where the money bag hangs.

81 a) He stands in his own light.

b) No one looks for others in the oven who has not been in there himself (only he who is wicked himself thinks ill of others; "Do not judge others by your own standards").

82 He plays on the pillory (having been put to shame, one should not attract attention to oneself; "People who live in glass houses should not throw stones"; also, to make an unjustified presumption).

83 He falls from the ox onto the ass (to make a bad deal; to fall on hard times).

84 One beggar pities the other standing in front of the door.

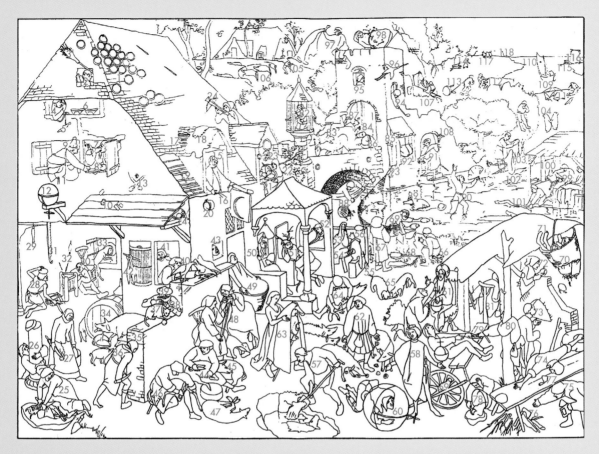

Drawing and explanations courtesy of the Gemäldegalerie, Staatliche Museen zu Berlin – Preußischer Kulturbesitz

85 Anyone can see through an oak plank if there is a hole in it.

86 a) He wipes his arse on the door (to make light of everything).
b) He goes around shouldering a burden.

87 He kisses the (door) ring (insincere, exaggerated respect).

88 He fishes behind the net (to miss an opportunity, wasted effort).

89 Big fish eat little fish.

90 He cannot bear to see the sun shine on the water (my neighbour's property bothers me and I am annoyed at the sun smiling in the water; envy, jealousy).

91 He throws his money into the water (to squander money; "To throw one's money out of the window"; "Money down the drain").

92 They both shit through one hole (inseparable friends).

93 It hangs like a privy over a ditch (a clear-cut matter).

94 He wants to kill two flies with one stroke (however, none will be caught; excessive ambition will be punished).

95 She gazes at the stork (she wastes her time).

96 To recognize a bird by its feathers

97 He hangs his cloak according to the wind (he adapts his viewpoint to conform to the circumstance at hand; "He trims his sails to the wind"; "He swims with the tide").

98 He tosses feathers in the wind (all his efforts are for nothing; to work unsystematically).

99 The best straps are cut from someone else's leather (it is easy to dispose of someone else's property).

100 The pitcher goes to the water (the well) until it finally breaks (everything has its limits).

101 He holds an eel by the tail (a difficult undertaking sure to fail).

102 It is ill to swim against the stream (one who revolts and is unwilling to comply with commonly held rules has a hard time of it).

103 He throws his cowl over the fence (he discards the familiar without knowing whether or not he can make it in his new surroundings).

104 This proverb has not been identified with certainty. The following meanings are possible:
a) He sees bears dancing (he is famished).
b) Wild bears prefer each other's company (it is a disgrace if one cannot get along with one's peers).

105 a) He is running as if his backside were on fire (he finds himself in great distress).
b) He who eats fire, shits sparks (whoever undertakes a dangerous venture should not be surprised at its outcome).

106 a) Where the gate is open, the pigs will run into the corn (everything is upside down when there is no supervision).
b) Where the corn decreases, the pig increases (in weight) ("One man's loss is another man's gain").

107 He does not care whose house is on fire as long as he can warm himself at the blaze (he seizes every opportunity to further his advantage).

108 A wall with cracks will soon collapse.

109 It is easy to sail before the wind (under optimal conditions one succeeds easily).

110 He keeps his eye on the sail (he is alert; "To know which way the wind blows").

111 a) Who knows why geese go barefoot? (there is a reason for everything).
b) If I am not meant to be their keeper, I'll let geese be geese.

112 Horse droppings are not figs (don't be fooled).

113 He drags the block (a deceived suitor; to slave away at a senseless task).

114 Fear makes the old woman trot (need brings out unexpected qualities).

115 He shits on the gallows (he is not deterred by any penalty; a gallows bird who will come to a bad end).

116 Where the carcass is, there fly the crows.

117 If the blind lead the blind, both shall fall into the ditch (when an ignoramus leads others, they will come to grief).

118 The journey is not yet over when one can discern church and steeple (the goal is reached only when one has fully completed one's task). One further proverb relates to the sun in the sky: Everything, however finely spun, finally com... (in the end, nothing remains hidden or u...

Demons in Our Midst

Bruegel's century saw the exploration of the Earth's surface, a fresh survey of the heavens, the examination of the human body, and the cataloguing of the animal and plant worlds. People's interest was focused upon what we today would call reality. At that time, however, many will have regarded as real, as existing, not only trees and animals, the liver and the spleen, but also demons. Scientific studies were unable to dispel handed-down popular belief. Many celestial phenomena, physical deformities, diseases and epidemics were as yet inexplicable, and were accordingly put down to the influence of devils and demons, together with their human accomplices. The latter alone, the witches and sorcerers, could be caught and punished. Thousands supposedly in league with the forces of evil – in particular women – were tortured, found guilty, and burnt at the stake.

Confessional reports and biographies reflect the great extent to which devils and demons were experienced as part of everyday reality. In the visual arts, they are given striking expression in the work of Hieronymus Bosch, likewise a Netherlander. Bruegel used his own fantasy to develop the tradition established by Bosch. He drew models for the prints of *The Seven Deadly Sins* (1558, detail p. 39) under commission from his publisher, Cock. Bruegel produced disturbing, unnatural landscapes filled with magical beings, in part playfully fantastical, in part genuinely threatening. It was presumably this mixture between the two elements, perhaps the thrill of fear, that was so sought after at the time.

The playful element is given less prominence in the artist's paintings, which are more serious in nature. Bruegel has depicted the origin of the demons in *The Fall of the Rebel Angels* (1562, ill. pp. 40/41), in which the Archangel Michael, together with his followers, is driving the angels who have rebelled against God out of Heaven. Falling to Hell, they are transformed into devils and demons. The proximity of God is indicated at the top edge by a brightly lit semicircle; furthermore, the upper – more heavenly – part of the picture is more clearly arranged and less congested than the lower one, approaching hell, in which the figures are chaotically falling past each other. A comparison of the angels and the devilish figures reveals that the former are clothed in lavishly swirling garments, leaving only their heads and hands visible. In contrast, most of the "evil ones" are naked, opening wide their mouths or tearing open their own bodies and – in some cases – presenting their buttocks to the observer's gaze. Bruegel has painted them merely as bodies, demonstrating the distance that lies between them and the spiritual beings, the angels.

The painter has also assembled the figures of the underworld around *Dulle Griet (Mad Meg)* (c. 1562, ill. p. 43), a traditional figure in Flanders who – also known as "Gret Sourpuss" – was always quarrelling with her husband or – under the name of "Black Gret" – passed herself off as Queen in the place of her mistress. Bruegel has depicted her as the embodiment of aggressive miserliness. Sword in hand, she is gathering up plates, pots and pans. The painter has turned upside down all the rules

Gula (detail), 1558
Gula means immoderation or gluttony and is numbered among the Seven Deadly Sins, which Bruegel portrayed in seven sheets full of fantastic figures and terrifying visions.

ILLUSTRATION PAGE 38:
Dulle Griet (Mad Meg) (detail), c. 1562
This painting (cf. p. 43) likewise contains a world filled with strange, diabolical figures, often made up of dissimilar parts. Here, a sitting figure with a boat on his back is spooning gold out of an egg-shaped rear.

The Fall of the Rebel Angels, 1562
The Archangel Michael, portrayed in golden-brown armour in the middle of the picture, is driving the angels who have rebelled against God out of Heaven. The angels in white garments are fighting on his side, while those who have broken away from God are meta-morphosing into the mostly naked bodies of fantastic figures.

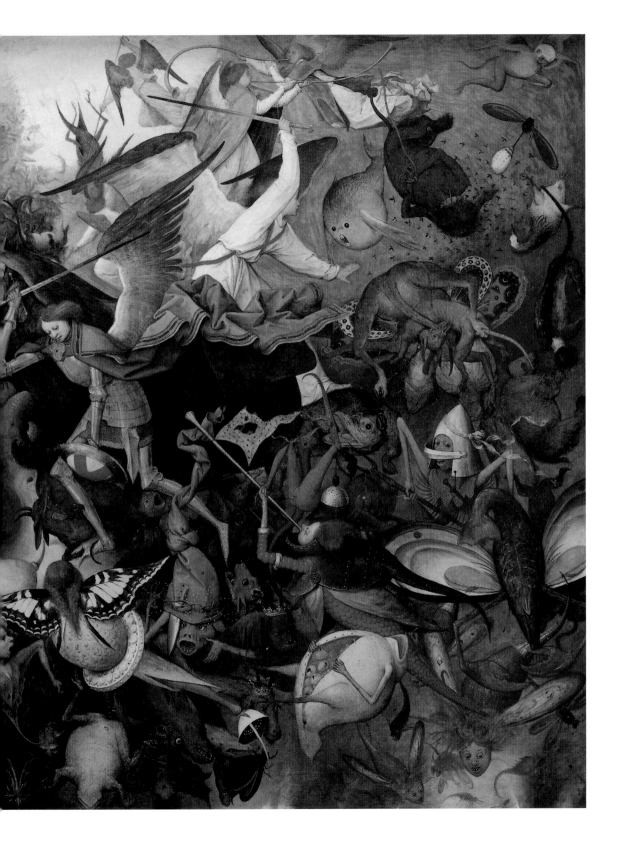

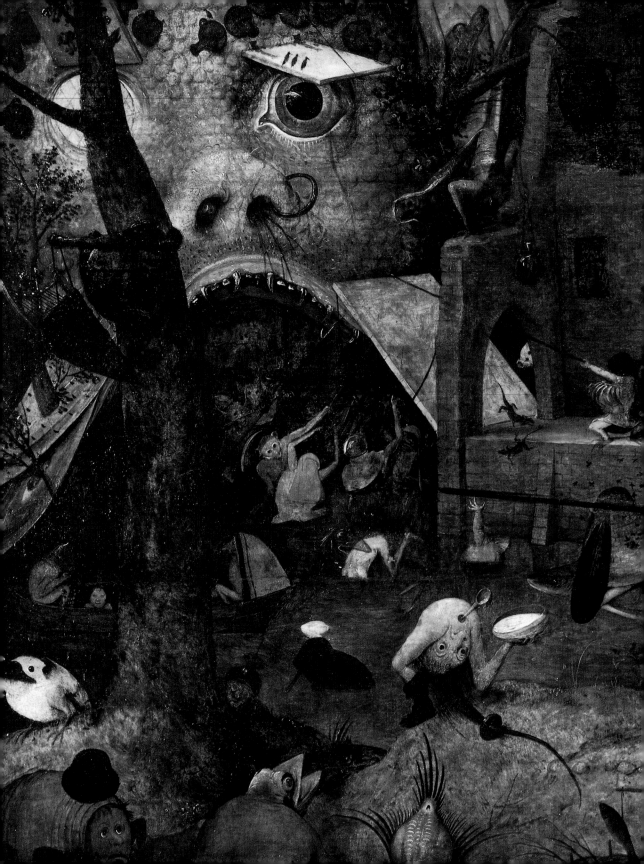

governing the pleasing presentation of women: no smile touches her lips; no hair plays about her brow; her skin appears dull; her toothless mouth hangs open; her clothes are shabby; her armour does not contribute to the elegance of her bust, but simply hangs in front of her belly. And instead of turning gracefully towards the observer, she is running past him with leaden steps, seeking to bring her booty to a safe place.

Yet she remains a human; she is no demon. The same is equally true of the women behind her. The devilish figures in this picture, in those few cases where their sex can be identified at all, are male. Their visors lowered, they are coming out from under the bridge, and are being tied by the women to cushions. "To tie a devil to a pillow" means to cope with the devil in question, or with a man.

Everything in the picture is the opposite of what it should be. The head which serves as the entrance to Hell has a board as its eyelid; its skin is made up of stones; a tree is growing out of its ear – the painter is repeatedly blending plant, animal, human, organic and inorganic elements. The mouth of Hell is part of a living creature and simultaneously an enclosed space; the crown on the forehead of Hell is simultaneously a wall with battlements; the eyebrows are comprised of jugs. It is a topsy-turvy world. The Divine order has no validity here. A hellish wall of fire blazes on the horizon.

Bruegel's first biographer, while providing us with information regarding the traditional figure, gives us no hint as to whether the painter was seeking to comment upon woman's position in contemporary society. From today's point of view, she was underprivileged. Her father and husband decided what was to be done with

Dulle Griet (Mad Meg), c. 1562
Bruegel has depicted a traditional figure as the embodiment of aggressive greed. She is running towards the gaping jaws of Hell, demons are raising a drawbridge, and we are left to guess whether Dulle Griet is seeking to bring her booty to a safe place or to conquer Hell. (Details pp. 38 and 42)

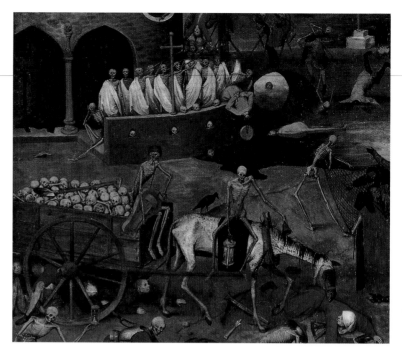

BOTTOM:
The Triumph of Death, c. 1562
An apocalyptic vision, the skeletons of death mowing down the living with scythes, en masse or individually: resistance is useless. Trees and grass are withered; the fires of Hell blaze behind the hills, and the Christian promise of resurrection and redemption is absent. (Details top and p. 45)

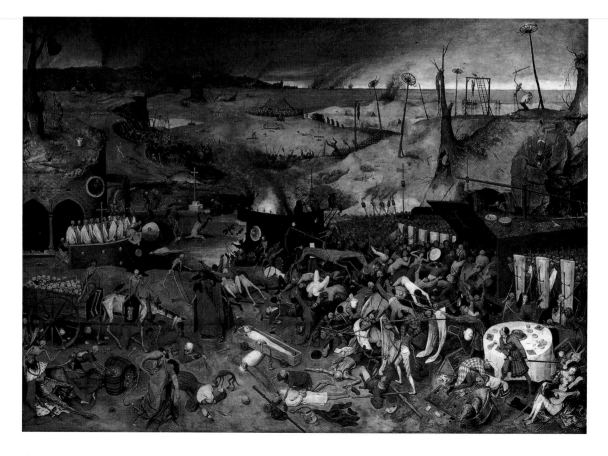

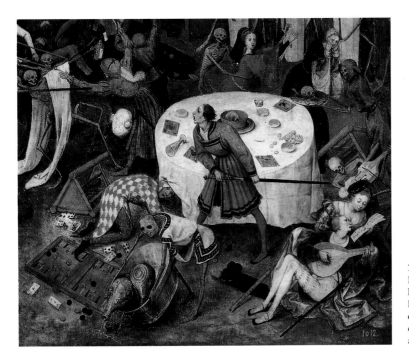

her property, while she was ousted from one of her most important occupational fields, that of popular medicine, by the university medicine practised by men. Only too often were midwives and "wise women" the victims of witch trials. Women were also underprivileged with respect to the Church, which expected them to be silent and considered them less perfect than man (who had been created first) and burdened by Eve's legacy as the eternal temptress. Though the women in this picture are stronger than the male half-beasts, they neither triumph nor exactly attract the observer's sympathy. It is unlikely that Bruegel intended any more than the creation of an aggressive, demonic environment for a traditional figure.

A third picture in this series has gone down in art history under the title of *The Triumph of Death* (c. 1562, ill. p. 44). We encounter not brutish demons up to their mischief but skeletons using scythes to mow everyone down, be he a king or a card-player seeking to defend himself with his sword, a mercenary soldier or a pair of lovers making music all unsuspectingly. It is a landscape of death, with withered grass, dead trees, and the fires of Hell burning once again in the background. The living are fleeing into a box, the door of which bears a cross; given the manner in which the box has been painted and the door held open above, however, they are running into a trap. God does not appear anywhere. Any indication of resurrection and redemption is absent.

This is no picture for purposes of admonition and edification in church. Bruegel is following no Christian dogma. He probably executed the three pictures, which are of similar size, for an unknown private patron, in 1562. Their quality and richness of invention bear witness to Bruegel's familiarity with the world of demons. Moreover, the observer occasionally has the impression that Bruegel's demons are also present in places where the artist has painted not some metaphysical terrain of horror and terrible figures but the natural world of Netherlands villages, people and landscapes. Demons in our midst? Demons in our very beings, at least in some of Bruegel's figures.

Village Life

The subjects most frequently treated by European painters in Bruegel's day and age were taken from the spheres of religion and classical antiquity. These included scenes from biblical history, repeatedly Christ on the cross, and – in Catholic realms – the Assumption of the Virgin Mary and the martyrs, along with the heroes and gods of the Greeks and Romans. "Venus and Amor" or "Adam and Eve" became favourite subjects for painters from Cranach to Titian on account of the opportunities they represented for portraying beautiful bodies. A third group was concerned with the portraits of high-ranking personages and self-portraits. The buildings to be seen in these pictures were commonly palaces and town or city halls – magnificent edifices, in other words, not crofts and thatched houses, not such dwellings as would call to mind the arduous life in the country.

The only exception here was the Adoration of Christ by the shepherds or the Wise Men from the East. However, the stable buildings in such pictures were generally idealized, and had little in common with the painter's actual environment. It was only in the Netherlands that things differed in this respect. Many artists in this country incorporated their everyday milieu into their pictures, painting not only rich and important men but also nameless people – the peasants, the agricultural workers, their dwellings, their villages.

In his day, Bruegel was the most important of these painters displaying a pronounced realistic touch. It is true that he included a biblical scene in his painting of *The Census at Bethlehem* (1566, ill. p.48); he depicted it so completely integrated into the pastoral life, however, that it can scarcely be made out at first glance. Mary on the donkey and Joseph in front of her differ neither in size nor in coloration from the other figures. The description of the village square struck the painter as being of greater urgency than the significance of the biblical characters. Bruegel selected an afternoon in winter, with the red sun already touching the horizon and the square full of people despite the cold. Such an outdoor life corresponded to everyday reality: while it was warmer in the houses, there was but little light indoors. Living conditions were cramped, all the members of a household often dwelling together in one single room. For these reasons, people in the 16th century spent more time on the streets and in the village square than in their houses, even in the north – a custom still followed today in southern countries. Children are enjoying themselves on the ice in Bruegel's painting; a hollow tree with a sign depicting a swan is serving as an open-air inn; and pigs are being slaughtered in the foreground, as was customary at the end of the year. The fact that this snowy day occurs before 24 December may be deduced from the account in Luke's Gospel, Chapter 2, in which Joseph and Mary travel to Bethlehem because the Emperor Augustus has ordered a census and everyone is to go to "his own town". Mary is in an advanced stage of pregnancy. The inn in the stable of which Jesus will be born could be the one in Bruegel's picture towards which Mary and Joseph are making.

A wreath indicates that the building is an inn or tavern. In Bruegel's painting, it

The Fair at Hoboken (detail), 1559
The dead were buried in the immediate proximity of the church; however, graveyards were not considered to be particularly solemn places.

ILLUSTRATION PAGE 46:
The Census at Bethlehem (detail), 1566
The sun is setting over a Flemish village. The wreath hanging over a building in the left foreground is an inn sign; the plaque next to it displays the double eagle, the crest of the Habsburgs. Philip II in Madrid was of the House of Habsburg, and taxes are being collected here in his name.

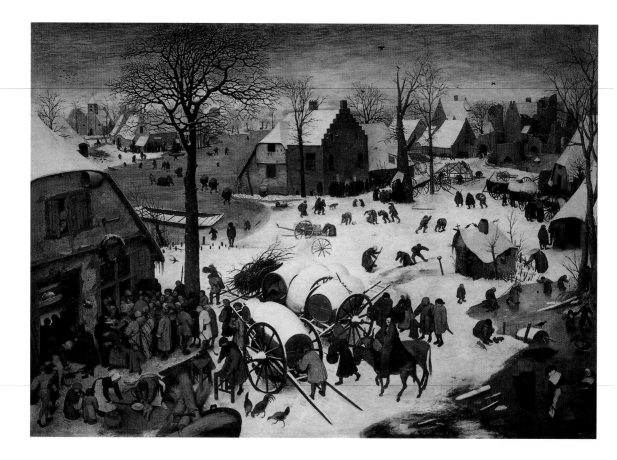

The Census at Bethlehem, 1566
There was next to no lighting within houses, apart from that thrown by the fire in the grate; accordingly, children and adults alike conducted their lives out of doors, even when it was cold. In the left-hand foreground, a pig is being slaughtered, a customary event with the onset of winter. Alcohol is being distributed at a treeside inn in the background, while the fires along the walls have a double function, not only warming the people but also roasting corn. (Details pp. 46 and 49)

also serves as the census-taking station. However, the painter has presumably taken not one of the rare registration actions but the collection of taxes as his source of inspiration: those standing in front of the window are paying their taxes, while the people behind the window-sill are receiving the coins and registering the amount in books. The office of tax collector was usually leased; however, the plaque next to the window with the Habsburg double eagle reveals in whose name the official is acting.

It is said that the financially flourishing Netherlands were required to find half of the taxes due from the huge Spanish Habsburg empire. The immensity of the sum gave rise to constant protests. Bruegel painted this peaceful picture in 1566; one year later Alba was to arrive, demanding additional contributions, a demonstrative act of oppression which would become one of the causes of the rebellion by the Netherlanders against Madrid.

Whenever Bruegel painted a village, he included a church in his depiction. This may be because of a wish on the part of the artist to comment in general terms on the importance of faith. It is more likely, however, that he painted or drew it every time because it represented a very real part of the village. The church was the community centre; it offered the possibility of coming together under one roof outside one's own cramped quarters, signalled the size and wealth of a village, performed not only a religious but also a social function.

The same was true of the graveyard. The engraving *The Fair at Hoboken* (1559, ill. p. 50) contains nothing of the gravity with which we enter graveyards today. Bruegel has depicted it as a general meeting-place. People are chatting, urinating,

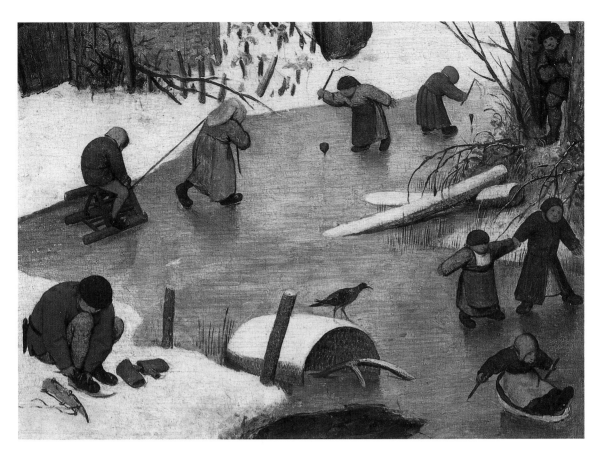

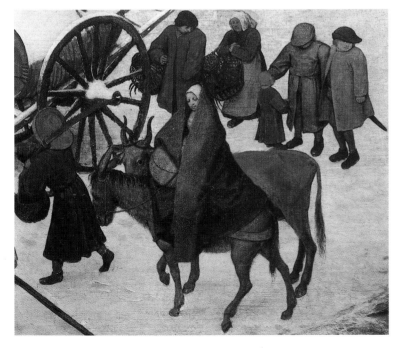

The Census at Bethlehem (details), 1566
Mary with the Christ child is sitting on a don-
key, the ox visible behind her. Joseph is strid-
ing out in front of them in the direction of the
inn where the tax collectors or census officials
are. Otherwise, no one in Bruegel's depiction
of a winter village square is interested in the
biblical figures. No one pays them any atten-
tion; children are enjoying themselves on the
ice with skates, tops, and a stool which has
been pressed into use as a toboggan.

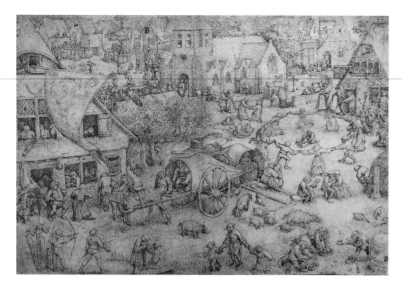

The Fair at Hoboken, 1559
We know regarding the Netherlanders that
they were fond of extravagant celebrations,
and would cover considerable distances in
order to participate in the festivities of other
places. At the bottom edge of the picture, a
fool is leading two children by the hand, in
accordance with the motto "Folly leads men".

here and there even dancing. Almost incidentally, a procession is crowding through
the church door, for the reason behind the origination of a fair is always a religious
festival. The main area of the drawing is filled with people enjoying themselves,
dancing, drinking, playing marbles or practising archery. The banner of the inn is
billowing out for all to see. At the bottom edge of the picture, a man in fool's cos-
tume is leading two children by the hand. By including this figure, Bruegel is seek-
ing to tell the observer that he is not only endeavouring to entertain with his port-
rayal of people enjoying themselves at a religious festival but also wishes to admon-
ish him: Foolishness leads people astray.

A fool is also strolling through the centre of the painting *The Fight between Car-
nival and Lent* (1559, ill. p. 51), illuminating the way of an adult couple with his
burning torch, although it is daylight – an indication of the "topsy-turvy" state of
the world, topsy-turvy perhaps because Catholics, depicted as skinny Lent, and Prot-
estants, suspected of being pleasure-hungry gluttons, are vigorously feuding with
each other. Bruegel has surrounded them with a wealth of traditional scenes: chil-
dren at play, cripples begging, fish-sellers, churchgoers with their stools, people
dressed up for processions.

The figure of the fool walking along in the centre of the picture reveals that Brue-
gel's interests lay beyond a mere depiction of communal life or carnival amuse-
ment. Some interpreters deduce from such pictures as this one that the painter was
primarily a "teacher of the people". They look for the didactic message in every one
of his works, treating each picture as a moralizing treatise. Thus, in the case of the
painting portraying a winter-bound village on a frozen river with ice-skaters, *Winter
Landscape with a Bird-trap* (1565, ill. p. 52), they are of the opinion that the blind-
ness to danger of the birds under the converted door must be seen in connection
with the foolishness of the people on the ice. It is surely not by chance, they argue,
that the two birds on the bush in the foreground, or the one in the top-right corner,
are as big as the people on the ice: the picture must surely be intended as an admoni-
tion to general prudence.[9]

Would the painter have hidden his warning so discreetly, however, if it had been
so important to him? Or was it perhaps meant by the painter as a little game for
those who are constantly seeking some prescription for life in every picture? Or,
again, could it be that what we see here is merely the chance product of perspective?

The fact that so much has been pondered and written on moral messages in Brue-

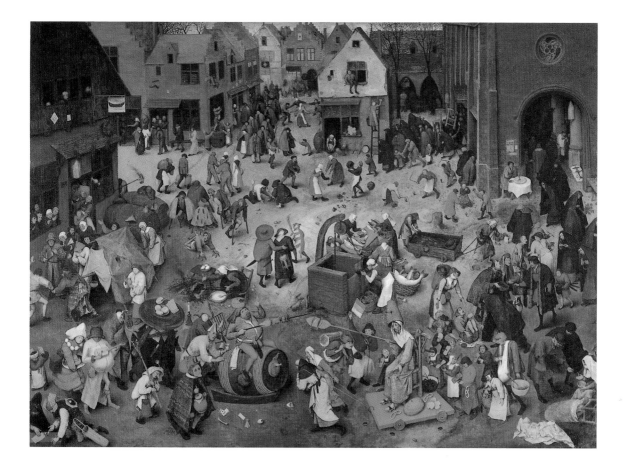

TOP:

The Fight between Carnival and Lent, 1559
The fat Lord of the Carnival astride the barrel
is intended to represent the Protestants, the
melancholy, lean figure with a beehive on his
head the Catholics. Bruegel is caricaturing
both equally harshly. In the middle of the pic-
ture, we again see a fool leading two people;
he has lit his torch, even though it is still day –
symptomatic of the topsy-turvy world.
(Details bottom and p. 90)

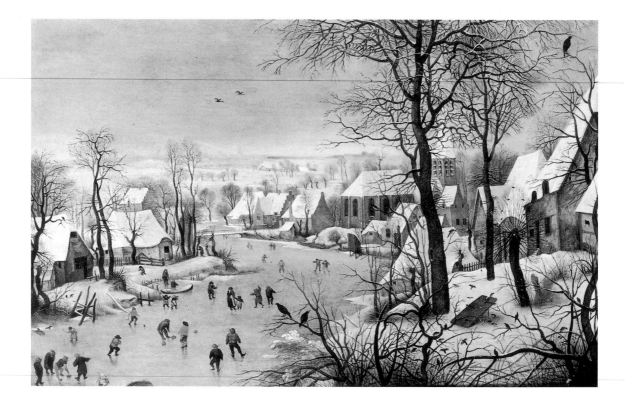

Winter Landscape with a Bird-trap, 1565
People are enjoying themselves on the ice; meanwhile, the birds are endangered through a door rigged to function as a deadfall. Since several of the birds have been painted as large as the people in the picture, some would interpret this work not only as depicting a winter landscape but also – primarily – as being intended as a warning to the observer to be on his guard against constant danger. (Detail p. 53)

gel's pictures is presumably due not least to problems of communication: it is easier to talk about morality than about art. That which renders a picture art cannot be described in words. The interpreter can give some indication regarding the selection of colours, for example, or the aesthetic function of some undergrowth in the foreground. He is unable to explain the artistic process – how the painter succeeded in conveying the variety of information contained in an actual winter landscape onto a piece of wood 38 by 56 centimetres large, in such a way that the colours and shapes give us the impression of a landscape spreading out quite naturally before our eyes – and, furthermore, how the painter uses his colours and shapes to produce a feeling of happiness in the observer.

Instead of attempting an explanation, van Mander, Bruegel's first biographer, cites a drastic comparison, transferring the artistic process of transformation into a bodily one. The comparison was prompted by Bruegel's mountains, van Mander writing that people said that Bruegel, "when he was in the Alps, swallowed all the mountains and rocks and spat them out again as painting boards."[10]

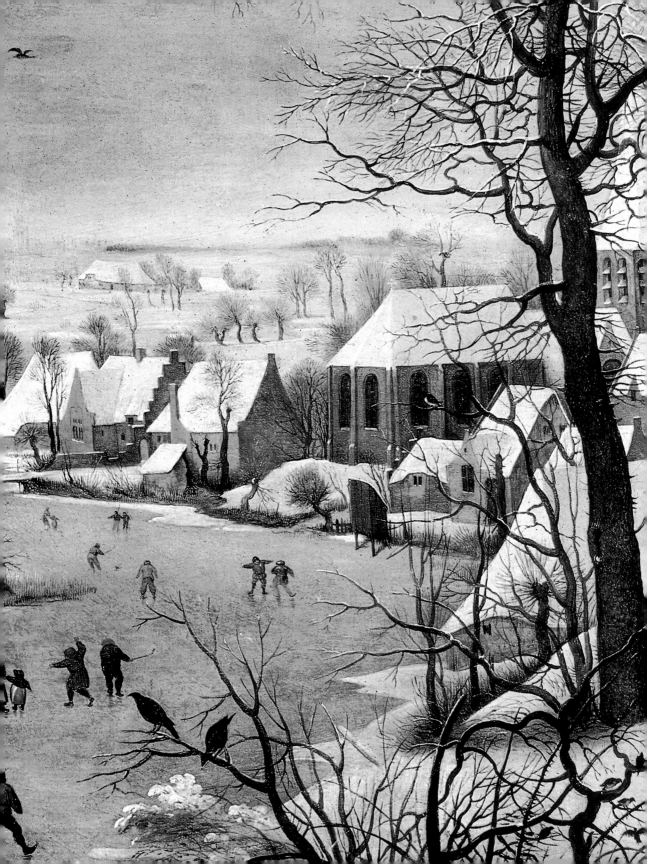

Nature as Man's Environment

In order to differentiate more easily between Pieter Bruegel the Elder and his paint-ing sons,[11] the former was later christened "Peasant Bruegel". "Landscape Bruegel" would have been equally fitting, since his depictions of landscapes are at least as original as those that he did of peasants. Today we would probably call him "Eco-Bruegel", after the sober and vivid manner in which he painted landscapes, portray-ing nature as man's environment.

It was not until Bruegel's century that the history of landscape painting really began. It had played a subordinate role in Christian painting towards the end of the Middle Ages; the subject of importance for mediaeval times was not so much one's visible surroundings as Heaven and Hell, and how one arrived at the one or the other. While landscapes were indeed reproduced in the book illuminations in the pos-session of the aristocrats, they were intended to show property ownership or profit-able ground – woods for hunting, fields for agricultural working. Not until one or two generations before Bruegel did people discover the attractive sight and aesthetic pleasure that a landscape could offer. The first master of this subject is generally ac-knowledged to be Joachim Patinier (c. 1485–1524).

The Netherlander Patinier is credited, among other things, with the decisive devel-opment – if not the invention – of certain techniques in the depiction of landscape. An example of this may be seen in the representation of distance, of spatial depth. While this can be depicted by means of foreshortening, such a technique works better in the case of buildings with straight lines than in the context of natural forms. Patinier achieved the effect of depth by using colours, painting the foreground dark, generally in earth brown, the middle ground green, and the background, where earth and sky flow into each other, light blue, thus proceeding from dark to light. Bruegel usually adopted a similar pattern.

Furthermore, Patinier used an elevated vantage-point to fit a broad area of land into his picture. It is only from above that one's gaze can pass over houses, trees, hills. Bruegel imitated him in this, almost all of his landscapes depicting the view from a mountain or some otherwise undefined height.

Not only painters and their patrons felt the need to chart as big a section of the Earth's surface as possible. For purely practical reasons, sea-captains and merchants with far-reaching trading connections required maps for long-distance routes. Brue-gel's friend Abraham Ortelius was among those offering such items; indeed, he be-came famous for producing the first world atlas to come onto the market.

This atlas included not only regional maps but also a map of the world, which, while of no practical value, was adorned with quotations of Roman philosophers. One of these states that man seems small if he considers "the entire eternity and size of the whole world". Another maintains: "The horse was created to pull and to carry, the bull to plough, the dog to keep watch and to hunt; man, however, was born to em-brace the world with his gaze."[12]

Both quotations belong to the body of ideas originating with the Stoa, the

Spring (detail), 1570
Bruegel has depicted people working in the garden; he produced the drawing for this post-humous engraving in 1565.

ILLUSTRATION PAGE 54:
Haymaking (detail), c. 1565
It was a part of understanding and studying na-ture that one come to appreciate more closely the differences between the various seasons. Bruegel succeeded in this in a highly indi-vidual manner.

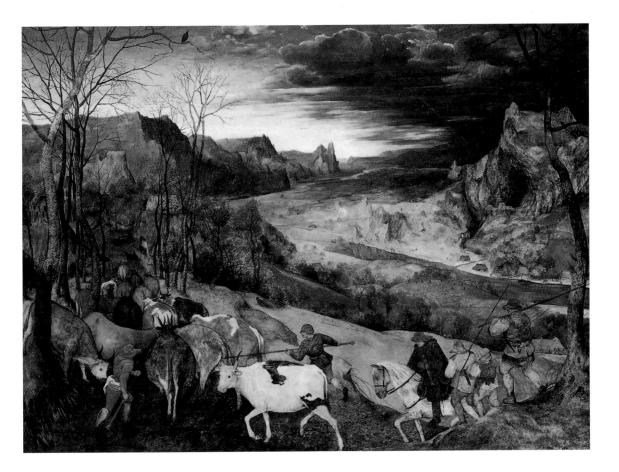

Graeco-Roman school of philosophy. The Stoics regarded the universe as a rationally ordered and beautiful structure in which every living thing has its allotted place and even man must fall into line and calmly accept his fate. Bruegel was doubtless familiar with these ideas of a rational universe, and there are indications that something of them or of the Stoic lifestyle found its way – whether consciously or not – into his pictures. Ortelius says of his friend that he "painted much that simply could not be painted. All of the works by our Bruegel always imply more than they depict."[13]

The philosopher's abstract, imaginary cosmos was the artist's visible nature, to which man must adapt and of which he is as much a part as the plants and the animals – as can be seen in *The Return of the Herd* (1565, ill. p. 57), for example. Cows, trees and people are all portrayed in the same hues. As observers, we of course know that the drovers have a particular responsibility; ultimately, however, they are of the same matter as the other living beings and must fulfil their predestined task, whether they will or not.

The Suicide of Saul (1562, ill. pp. 58/59) can also be interpreted in terms of Stoic thought. King Saul was guilty of arrogance: he did not obey Yahweh, God of the Old Testament; alternatively, in the sense of the Stoics, he offended against the laws of the universe. Accordingly, he had to die. We see on the left of the picture how, threatened by a superior enemy, he has fallen upon his sword. His squire is in the process of following suit. However, the struggle between the two armies is depicted as that between two caterpillar-like armoured entities equipped with prickles. It is a battle not

The Return of the Herd, 1565
Many of Bruegel's paintings show people not so much as the masters of nature but rather as a part of it: there is hardly any difference here between the coloration of the cattle and that of their drovers. *The Return of the Herd* is one of a cycle depicting either the seasons or the months, five paintings of which have survived. This picture presumably depicts November. (Detail p. 56)

ILLUSTRATION PAGES 58/59:
The Suicide of Saul, 1562
Bruegel has shifted the scene of the battle between the Israelites and the Philistines to an extensive landscape, portraying not the struggle between individual soldiers but that between masses of fused armoured entities equipped with prickles. People like King Saul and his squire, who have both thrown themselves upon their swords, appear small and insignificant against the broad expanse of nature.

of individuals but of masses. Nature and the cosmos resolve the affair; anyone rising up against them will perish.

Bruegel must have been preoccupied with or even disturbed by the rebellion against Nature, the cosmos, God, the motif of hubris, for he treated it again and again. In addition to Saul, we can find King Nimrod with the uncompleted Tower of Babel, the rebellion of the angels against God and their fall, and also the man who foolishly attempts to defend himself with his sword against triumphant Death. Furthermore, it is presumably anything but by chance that the subject of the sole legendary motif from classical antiquity to be found in his œuvre, namely the fall of Icarus (*Landscape with the Fall of Icarus*, c. 1558, ill. p. 61), is precisely hubris.

The legend relates how Daedalus made a pair of wings for himself and his son, Icarus. He used feathers, thread and wax to do this, and he warned his son not to fly too close to the sun. Icarus, in high spirits, did not heed his father's warning; the wax melted, and Icarus fell into the sea. All that can be seen of him in Bruegel's painting are two legs in the water.[14]

Icarus is often venerated as an explorer attempting to push back the boundaries of knowledge. Bruegel sees him differently, rendering him ridiculous with his helplessly thrashing legs. He has painted the man with his plough, concentrating fully on horse and furrow, larger than Icarus. The best-known version of the Greek legend circulating at the time, a free rendering of Ovid, mentions the farmer, the shepherd depicted by Bruegel, and also the angler, relating how they look up at the two flying humans and "are astonished and think to see gods approaching them through the aether."[15] In the picture, it is only the shepherd who is looking upwards; neither he, nor the farmer, nor the angler, do anything about the drowning boy, however, but continue with their tasks. Even the shepherd remains with his flock. They are

TOP:

Man of War with the Fall of Icarus (detail), undated
The engravings for which Bruegel produced drawings were always intended for a large clientele. For this reason, they tended to follow the conventions to a greater extent than was the case with his paintings. Icarus was generally portrayed close to the sun, as here, with his father, Daedalus, at a suitable distance below him.

"stoics": they obey the laws of the cosmos and leave the lawbreaker to his supposedly just fate.

In concentrating on the people, it is easy to forget that they occupy but a fraction of the painting's surface. They are visually enveloped by a bay with a wood, mountains, a harbour in the distance, and the sun setting on the horizon. Bruegel has unfolded an unrealistic variety and an almost immeasurable expanse. He is demonstrating man's insignificance compared to the "size of the whole world" as quoted by Ortelius.

In order to render spatial depth, Bruegel once again places the observer on an elevated point so that he sees the farmer from diagonally above, the shepherd more side-on, and the ship above the latter frontally. While this may not be quite true to perspective, this technical trick of angular displacement heightens the impression of great distance which the painter was evidently seeking to convey.

Bruegel also occupies an important position in the history of landscape painting on account of his ability to convey to the observer the transformation of nature in the course of the seasons. This was no new subject. The religious texts in the illustrated prayer-books of the nobles in the late Middle Ages were often preceded by a calendar with a page for each month. These pages showed the course of the year, mainly by depicting the respective occupations carried out in the month in question. Thus in January, the feudal lords invite their guests to an opulent banquet; in February, the peasant cuts wood; in March, he tills the soil; in April, young aristocrats celebrate their betrothal in the country; in May, they go horse-riding; and so on. These miniatures are characterized by people. In Bruegel's art, it is always Nature itself which renders the season apparent: like the trees and animals, the people represent merely one part of the broad landscapes spread out before the observer.

Landscape with the Fall of Icarus, c. 1558
Wearing wings held together with wax, Icarus approached too close to the sun; the wax melted, and Icarus fell into the sea. Bruegel makes him look ridiculous, depicting merely his thrashing legs. Through the farmer, the shepherd and the angler, he is promulgating Stoic ideas: one should not rebel against the laws of the cosmos, but should be content to fulfil one's tasks in the appointed place. (Detail p. 60, bottom)

This is especially evident in the painting *The Hunters in the Snow* (1565, ill. p. 63). There are no shadows: the sun has set, or is hidden behind unbroken cloud. Snow covers the ground and small plants, while gigantic, ice-coated mountains loom in the background. The picture is dominated by two "cold" colours, the white of the snow and the pale green of the sky and the ice. Every living thing – people, trees, dogs, birds – is dark. This stands in contradiction to the customary colour associations connected with being alive, and heightens the impression of misery and privation. The hunters are bringing only one fox home with them – yet it is not they who communicate to us that it is wintertime but first and foremost Nature, the colours of the sky, the ice, the snow, by means of which Bruegel has characterized this day.

Quite the opposite is true of the picture *Haymaking* (c. 1565, ill. p. 64). The range of colours is richer, white being used solely for a horse and for clothes, while the landscape is displayed in many shades of yellow, green and blue, with the fruit and articles of clothing in the foreground even painted bright red. Bruegel also uses landscape forms to render seasons (and the feelings we associate with them) visible. Large areas of the landscape in the picture of winter are flat, as though pressed down and deadened by the ice and snow. In the case of early summer, on the other hand, he depicts a varied, rolling, hilly landscape; he has even animated the sky, painting it not as a monochrome surface but bright above the horizon and a rich blue at the upper edge, and also adding clouds. This comparison reveals the means employed by Bruegel – in addition to the concrete details – to heighten the impression of the harshness of winter or the vitality of early summer.

***The Hunters in the Snow**, 1565*
The painting may strike the observer as a natural view of the landscape, but in fact it reveals Bruegel's great artistry in stylization. The picture is dominated by two "cold" colours, namely the white of the snow and the pale green of the sky and the ice. People, trees, dogs, birds are all dark or black, thereby contradicting the customary colour associations: winter brings sleep and death. (Detail p. 62)

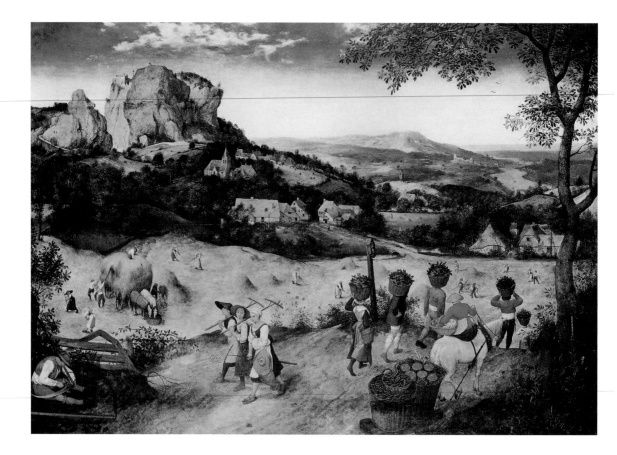

The painter even makes use of the figures to characterize the seasons. In the one instance, weary hunters with drooping shoulders are turning their backs upon the observer. In the other, three young women are energetically striding past the observer, one of them even looking straight at him. If one takes the group of women together with that formed by the three basket-carriers, one might even be tempted to think of a dance-like arrangement, of choreography. Such rhythm is rare in Bruegel's art; it, too, reinforces the impression of vitality and joy of living in harmony with Nature.

The Return of the Herd, *The Hunters in the Snow* and *Haymaking* belong to a cycle of paintings depicting the months of the year, all with the same format and probably executed for the same patron. Five of these months have survived, the other two being *The Corn Harvest* (1565, ill. p.65) and *The Gloomy Day* (1565, ill. p.67).

No figures striding out with dance-like steps may be seen in *The Corn Harvest*; quite the opposite, the fieldworkers are exhausted, are lying or sitting, eating or sleeping. Each of these paintings has a dominant colour or combination of colours; here it is the yellow of the corn, ripe for harvesting.

The Gloomy Day was presumably intended as a reference to February, the carnival month. A minstrel is standing in front of the "Star" inn in the village at lower left, and a boy in the right-hand foreground of the picture has fixed a paper crown to his brow, while another is eating a waffle, something commonly consumed at carnival time in those days. Two men are cutting and bundling willow branches, a typical wintertime occupation. The flexible branches were required for the weaving of fences and walls.

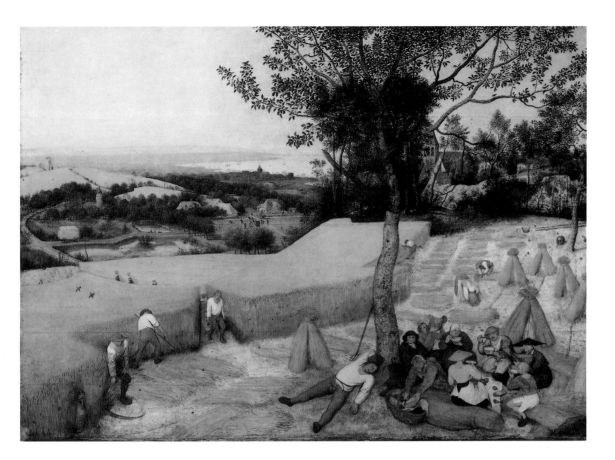

Once again, however, it is not the people who determine the picture of the season but Nature, which manifests itself so much more powerfully. It is Nature in which man must assert himself, in which he finds enjoyment, but which he is also unable to affect in any way.

Man's impotence is reflected in the storm-lashed sea and the sinking ships. Bruegel has dramatically illuminated the snow-covered mountains in the background. The slope in the foreground on which the people are working appears perilous. Perhaps it was the storm which uprooted trees on the hill. One almost has the impression that the dark earth, rudely awakened from its winter sleep, was attempting to rise up in revolt.

Bruegel's very different landscape pictures must be seen as a whole and compared with one another in order to fully appreciate the artist's achievement. Never before had the transformation of nature in the course of the seasons been so convincingly captured in pictorial form. Indeed, no-one before – nor perhaps since – has depicted landscapes in such a varied manner, with such an absence of sentiment. A new outlook is revealed here, one influenced by a philosophical conception of the world and sharpened by contemporary interest in natural history and the globe as a whole.

The Corn Harvest, 1565

ILLUSTRATION PAGE 64, TOP:
Haymaking, c. 1565 (Detail p. 54)

ILLUSTRATION PAGE 64, BOTTOM:
The Limbourg brothers:
The Month of March from the "Très Riches Heures du duc de Berry", c. 1415
The books of hours owned by nobles characterized the months through work in the fields or aristocratic amusements. Castle buildings in the background served to draw attention to the lord of the manor. In the case of Bruegel's paintings, the picture is dominated by nature, with the workers an element of it.

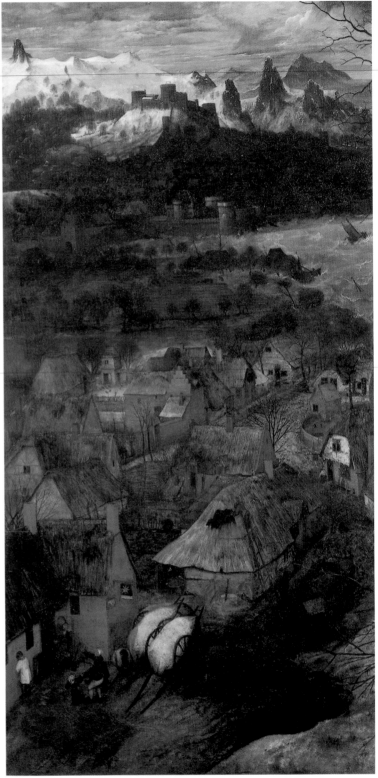

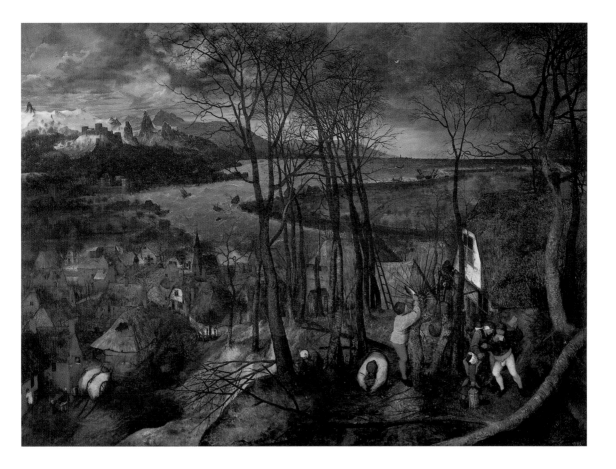

The Gloomy Day, 1565

This painting alludes to January or February. The paper crown on the
boy's head refers to Epiphany, the Festival of the Three Magi; waffles
were commonly consumed at carnival time prior to Lent. Following the
custom at this season, willow branches are being cut for the construction
of walls and fences. The mountains in the background demonstrate the
threatening proximity of cold and snow; a further source of threat can be
seen in the storm whipping up the waves and causing ships to sink. The
Netherlanders were a seafaring people; they knew how dangerous the
winter months are at sea. Water, mountains and the near intimacy of the
foreground are held together by the picture's particular coloration. The
towering trees in the middle serve to anchor the agitated landscape.
(Details p. 66)

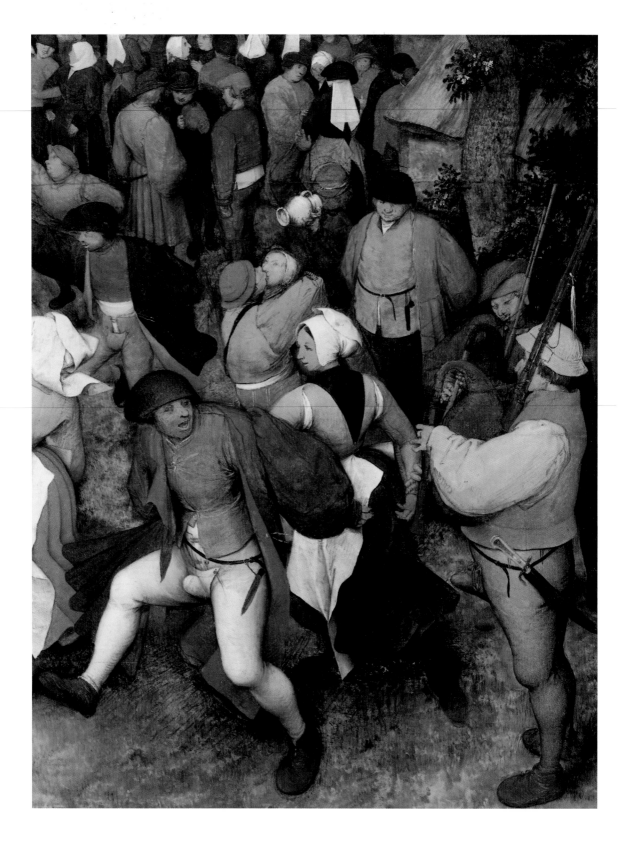

Not only Peasants

We may learn a great deal about an artist by identifying the things he does not paint. As far as we are aware, Bruegel painted no portraits on commission, nor – even more significant – any nudes. The nude human body had been a favourite subject since the Renaissance. Artists vied with each other in their search for the perfect body, and young painters in the 16th century were advised to construct an ideal figure from the particularly beautiful limbs of different persons, that they might thereby "achieve a harmony such as Nature only seldom affords."[16] People should be more perfect than Nature, for – as one argument ran – man is made in God's image, and it is the task of the artist to bring out this similarity.

In Bruegel's art, by contrast, the only naked beings are demons. His people are dressed and often so wrapped up that their bodies are quite unrecognizable – a far cry from the well-proportioned or elegantly stretched figures of the Italians and their followers in Spain and the north.

Of the portraits ascribed to him, only one is indisputably by Bruegel: the *Head of a Peasant Woman* (after 1564, ill. p.70). This work, like with many figures in his other paintings, reveals his great talent for capturing faces. We may be sure that Bruegel did not lack requests for portraits, the newly wealthy citizens being all too eager to have themselves and their families immortalized in this manner. However, he was evidently unwilling to bother himself with that sort of thing.

The emphasis upon the importance of the individual, which emerged in the Renaissance did not fit in with his artistic concept. Indeed, Bruegel often hid the faces of the figures in his drawings and paintings, rendering them unrecognizable as individuals. Of the six persons in the foreground of the drawing *Summer* (1568, ill. p.71), only one face is visible, and that foreshortened; in *The Beekeepers and the Birdnester* (c. 1568, ill. p.71), the observer feels it was precisely this display of anonymity which so attracted Bruegel.

A similar tendency may be observed in his biblical figures. He pushes them to one side, or hides them between secular figures of the same size. Thus we encounter Mary and Joseph in the village square, St. John the Baptist with Christ in a crowd of people, and the Adoration of the Kings behind a curtain of falling snow. Over 30 of some 45 pictures by (or attributed to) Bruegel are characterized by Nature, by the village and its peasants; the anonymous representatives of the rural lower stratum become the principal characters in his œuvre.

No painter before him had dared produce such works. Contemporary art generally regarded peasants as figures of mockery, considering them stupid, gluttonous, drunken, and prone to violence. It is as such that they appear in satirical poems, tales, and Shrovetide plays: as a well-known negative type, an object of laughter. They were used by authors to amuse the reader, and also to warn him to beware of bad qualities and wrong behaviour.

As has already been observed, a desire to warn and instruct is still regarded by some as the primary aim of Bruegel's work. Yet we must ask if *The Peasant Wed-*

The Beekeepers and the Birdnester (detail), c. 1568
Honey was the most important sweetener in those days. The colonies of bees were smoked out in autumn; the peasants would then catch new colonies in spring.

ILLUSTRATION PAGE 68:
The Wedding Dance in the Open Air (detail), 1566
The bagpipes were considered to exert an especially erotic effect. This portrait of a boisterous dance is a celebration of vitality and fertility. Bruegel has particularly emphasized the codpieces worn by some of the men.

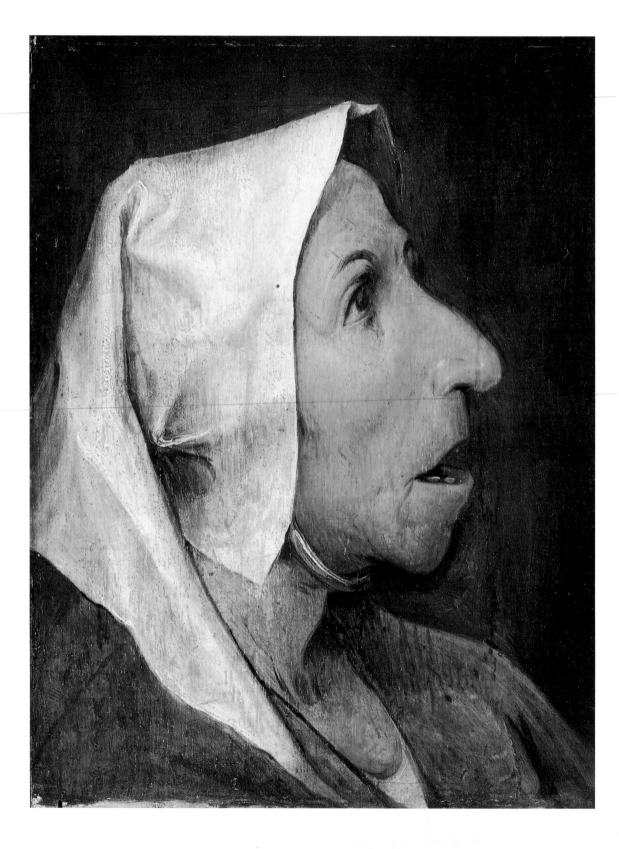

ILLUSTRATION PAGE 70:

The Beekeepers and the Birdnester, c. 1568
Bruegel will have found a special attraction in
the opportunity offered him by the beekeepers
of portraying them as anonymous, faceless
people. (Detail p. 69)

Head of a Peasant Woman, after 1564
Bruegel painted no commissioned portraits,
nor any of prominent contemporaries. He was
uninterested in any cult of personality. How-
ever, this portrait of a peasant woman reveals
just how capable he was of portraying faces
with highly individual features.

ding Banquet (1568, ill. p. 73) in the barn – to take but one example – was really
painted with the intention of keeping the observer from gluttony. Men and women
are sitting solemnly and thoughtfully at table; the helpers are carrying round a
simple porridge on a door which has been taken off its hinges; the bride is sitting
motionless under her bridal crown. On the right, a monk is conversing with a gentle-
man dressed in black. Though wine or beer is being poured into jugs in the fore-
ground, there is no trace of drunkenness or gluttony among the wedding party. In-
deed, they do not even appear particularly cheerful. Eating is portrayed as a serious
activity. Moreover, the wall of straw or unthreshed corn and the crossed sheaves
with a rake serve to keep in mind the labour by which the food is wrested from the
soil.

In Bruegel's time, such a scene depicting people at table will have reminded ob-

Summer, 1568
Here, too, Bruegel has avoided depicting
people as individuals, hiding or foreshorten-
ing the faces and concentrating upon the
human body at work.

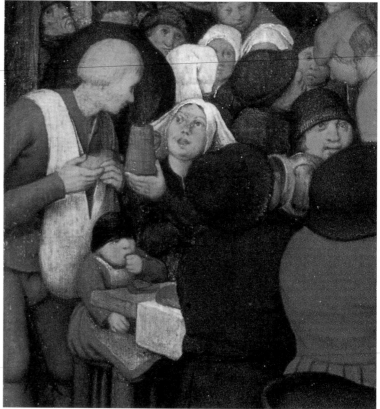

TOP:

Paolo Veronese:
The Wedding at Cana (detail), 1562/63
Painters who idealized people as beautiful or
cerebral beings did not depict them eating –
no spoon or bite to eat on its way mouthwards
was visible; instead, people sat chatting in
front of their plates. Quite the opposite was
true in the case of Bruegel, who emphasized
the material existence of people, showing the
body's need of nourishment.

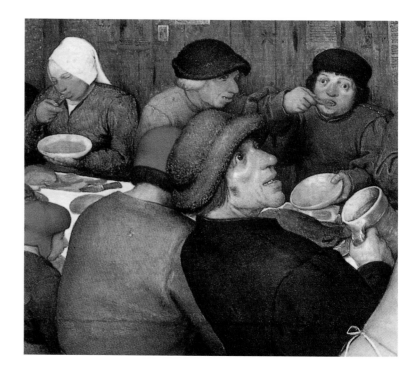

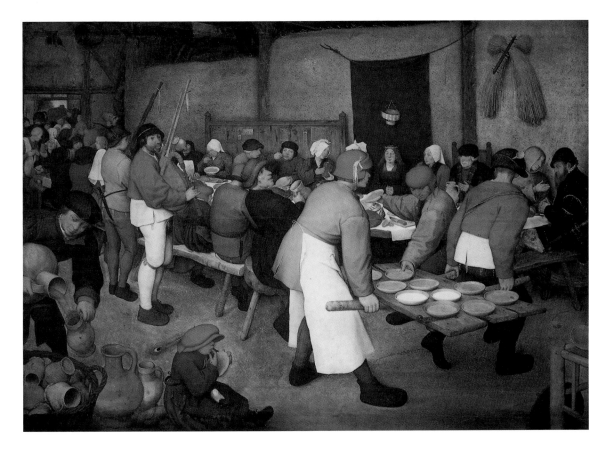

servers of the Wedding at Cana, as described in the second chapter of St. John's Gospel. The story of Christ turning water into wine was often referred to in contemporary works. Traditional representations required a large company at table and – as in Bruegel's painting – a man filling jugs. Jesus and the wedding guests were not portrayed in the act of eating, however – not even in those instances where the artist had shifted the wedding to his own time.

It was a fundamental given in Bruegel's century that saints, nobles and burgher families were never depicted eating; they might be shown sitting at table, but were not allowed to touch the fare before them, nor even to open their mouths, let alone put anything into them. This drawing a veil over the act of eating must have been in accordance with an unwritten rule. In all probability, people found it disconcerting to be reminded of the fact that no-one, no matter how rich, or how powerful, or how spiritual he may be, can live without nourishment – for eating reminds us of our dependence upon Nature, our dependence upon our digestive organs. This was at odds with a concept of art in which man was idealized, one seeking to make man in God's image, to render him a superior individual.

Bruegel had no inhibitions in this respect. Two figures in his *Peasant Wedding Banquet* in the barn have their spoons in their mouths, one guest has set the jug to his lips, and the child in the foreground is licking his fingers. The same may be encountered in *The Corn Harvest* (ill. p.65), where the midday break during work in the field means spoon in mouth, jug and dish set to lips.

One might gain the impression that Bruegel was confirming the prejudice against the peasant as a being at the mercy of basic needs, one at whom the man of education might laugh. A closer examination of his figures reveals this to be incorrect,

The Peasant Wedding Banquet, 1568
The bride is sitting under her bridal crown; it is unclear which of the others is the bridegroom. The feast is taking place in the barn, the wall behind the guests consisting of stacked-up straw or corn. Two ears of corn with a rake call to mind the work that harvesting involves. The plates are being carried around on a door taken off its hinges. The principal form of nourishment in those days consisted of bread, porridge and soup. (Details p.72)

The Land of Cockaigne (detail), 1567
You must eat your way through a mountain of porridge to reach the land of Cockaigne, the proverbial "land of milk and honey". There, the fences are made of sausages, the geese lie ready-grilled on the plates, the pigs bring knives with them, and what one might take to be cacti are in fact made of oatcakes.

however. Furthermore, executing a large-format painting merely in order to poke fun at someone would contradict the custom of the times: mockery was the realm of cheap prints. Finally, Bruegel has indicated in his picture *The Land of Cockaigne* (1567, ill. p. 75) that he was thinking not only of peasants in connection with a dependence upon nourishment. It is not just a peasant we see lying there, but also a noble warrior and a scholar. Bruegel has bedded them down in different ways, the aristocrat sleeping on a cushion, the scholar on a fur cloak, the peasant on the flail with which he threshes the corn. All three have eaten their way through the mountain of porridge; all three have crammed themselves with eggs, meat and poultry before sinking into sleep, their bellies full.

Bruegel portrayed the significance of eating over and over again; in doing so, however, he did not draw a veil over the excretion of what had been digested. In several of his paintings, a man may be seen standing against a wall, his back to the observer (e.g. *The Massacre of the Innocents*, ill. p. 12; *The Gloomy Day*, ill. p. 67; *The Census at Bethlehem*, ill. p. 48), or even in a squatting position, presenting the observer with bared buttocks (*The Fair at Hoboken*, ill. p. 50; *The Magpie on the Gallows*, ill. p. 82). Yet the artist remains discreet, leaving women out of such actions, giving no undue prominence to this emptying of the bowels. Nevertheless, the fact that he should consider such a thing at all worthy of depiction distinguishes him from almost all his contemporaries, particularly from the Italians and the so-called "Romanists" who were their pupils.

The Italians and Romanists emphasized what distinguished man from the animal and plant world. Bruegel, in contrast, emphasized their similarities, the natural, "begotten, not made" element in man. In the words of the Creation story, "the Lord God formed man of the dust of the ground, and breathed into his nostrils the breath of life" (Genesis 2:7) – Bruegel sees not just the divine breath but also the material, the dust of the ground.

This may be observed in many of his pictures, in widely differing motifs. *The Wedding Dance in the Open Air* (1566, ill. pp. 76/77) and *The Peasant Dance* (1568, ill. p. 79), for instance, convey an impression of vitality, through a whole host of people, movement, and vivid colours. It is not from the head that vitality comes, however, but from the body, from the belly. Bruegel has emphasized the codpieces among the wedding guests; contemporary fashion demanded that one dress up the male sex organs, but the painter has set them off to even greater advantage. Fertility and reproduction are vigorously celebrated in his *Wedding Dance in the Open Air*.

A further example is *The Parable of the Blind* (1568, ill. p. 81). This painting is not packed with colourful movement; rather, it is dominated by a diagonal running towards the lower right-hand corner. We observe a row of men, successively losing their footing and tumbling to the ground as if in slow motion. There are no provoking contrasts of colour; the range is reduced to shades of brown and bluish grey. Whereas the dance portrayed "joie de vivre", here we are presented with misery and the end. The blind leading the blind referred in literature, and presumably also in everyday language, to foolishness or wrong behaviour. "And if the blind lead the blind, both shall fall into the ditch," Christ is supposed to have said (Matthew 15: 14). He was referring to the Pharisees, whereas Bruegel takes the proverb literally: blindness diminishes man, robbing him of his orientation in the world. The artist portrays, with a brutality unequalled in any of his other works, how helpless and exposed to disaster someone is who, while having a body, is unable to use his head properly.

It would thus be erroneous to claim that Bruegel was celebrating solely the vitality in man, solely that quality disparagingly termed "animal", solely that realm

The Land of Cockaigne, 1567
A peasant, a knight and a scholar are lying with full bellies under a tree around the trunk of which a tabletop has been fixed. The squire, wearing some pieces of the knight's armour, is keeping watch, hoping that something will fly into his mouth. Behind the fairytale fantasy of the land in which there is nourishment in abundance lies the experience of ever-recurring famine. (Detail p. 74)

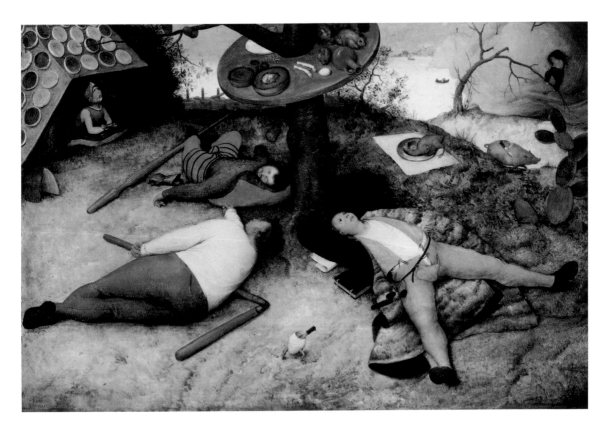

The Wedding Dance in the Open Air, 1566
A picture of bright colours and brilliant colour
contrasts, with people in boisterous motion al-
most to the very edges. Bruegel has painted a
company full of scarcely controlled vitality,
adding many realistic details: the bridal crown
has been affixed to a cloth in the background,
in front of which money is being collected on
a table, while ditches have been dug out fur-
ther to the left, on the edges of which the com-
pany will sit to eat. (Detail p.68)

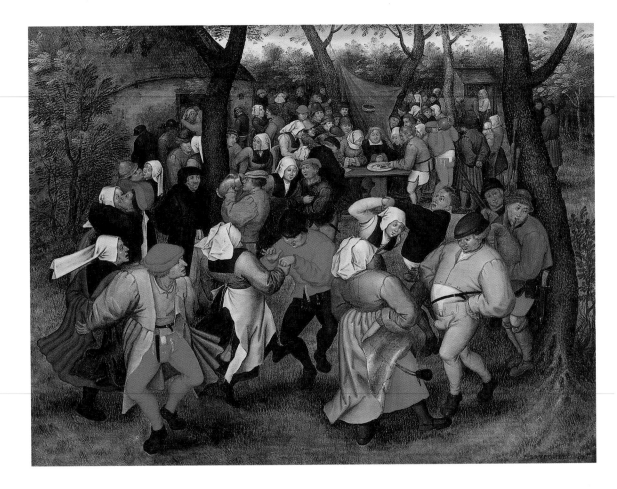

Pieter Bruegel the Younger:
Peasant Wedding Dance, 1607
The son has produced a variation upon a
theme of his father's (cf. pp. 76/77), and a
comparison of the two works sheds light upon
the particular vision of the older Bruegel. The
father's work reveals a turbulent crowd of
people, vitality, potential violence, with the
figures seemingly bursting out of the frame.
That of the son displays idealized faces and
clear groupings, while the rather harmless fes-
tivities are held in check by the absence of
figures in the areas along the border.

which is also filled with violence or inhabited by demons. His demons are naked;
they tear open their bellies, reveal their innards, point their buttocks at the observer;
they are only body and digestive organs, without spirit. In contrast, his people are
dressed and therefore civilized. Bruegel gives them neither noble faces nor a form
prettified in accordance with some intellectual concept, as are the features en-
countered in works painted in Rome, Florence and Venice. Bruegel demonstrates
that the natural, uncivilized realm of man is a constituent element of his natural
make-up, and the basis of his existence. No body means no soul. Man rises above
Nature, yet is also a part of it.

At the end of his life, Bruegel was to display once more in a landscape painting,
The Magpie on the Gallows (1568, ill. p. 82), this attachment to and affinity with
everything that grows and passes. Once again, the observer is looking down from
an elevated point upon woods, meadows, cliffs, and a river reaching the sea just
below the line of the horizon. We could perhaps speak here of a Bruegelian stan-
dard motif. A watermill stands in the valley. The picture is framed by lofty trees
towering up on both sides.

Here again, as in his early paintings, the artist has populated the broad landscape
with the little figures of people – people dancing, making music, strolling, chatting,
one person in the left-hand foreground relieving himself with exposed buttocks. We
might be reminded of the Stoics, of their statement to the effect that man seems
small if he considers "the entire eternity and size of the whole world". Yet Bruegel

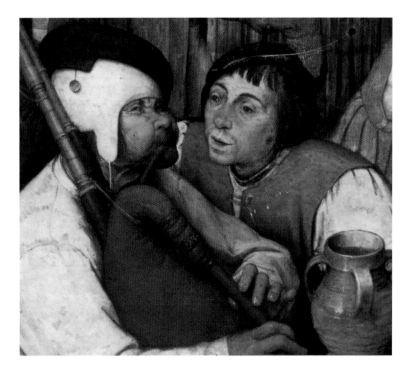

BOTTOM:

The Peasant Dance, 1568
The running and jumping steps of the village-square dance have nothing in common with the formal dances performed at court or in bourgeois circles. Nor do we find here the care for and adornment of one's face customary in more elevated circles, by means of which supposed faults of nature were to be corrected. (Detail top)

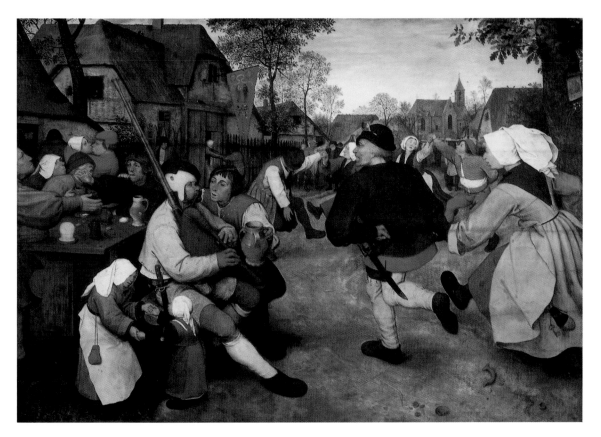

The Parable of the Blind (details), 1568
Blind people roamed the country in groups
begging; they were part of the street scene.
Bruegel has painted them with no trace of
sympathy, but so accurately that it is possible
for doctors today to diagnose the various eye
disorders or the causes of blindness: the man
on the left is suffering from leucoma of the
cornea (so-called "wall-eye"), and the one on
the right from amaurosis, while the eyeballs
of the blind man in the detail below have been
gouged out, perhaps as punishment, perhaps
in connection with an argument.

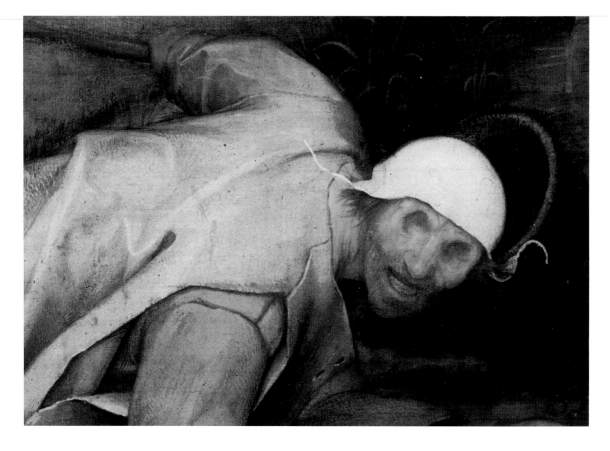

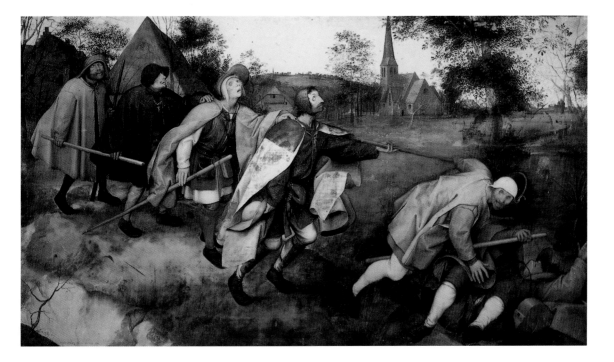

goes a step further. His figures all have similar faces; they are not to be recognized as individuals; they appear clumsy living things – and the distance separating them from the animal and plant worlds seems insignificant. Not only are they small; in Bruegel's specific way, they are also integrated into Nature, safe and secure in the artist's expanse of landscape.

The Magpie on the Gallows (ill. p. 82) is the painting Bruegel is believed to have left to his wife, with the comment that he was referring by magpies to the gossips he would like to see hanged. As already mentioned, the gallows was specifically associated with Spanish rule, the authorities having earmarked a shameful death by hanging for the "predicants", the preachers who were spreading the new Protestant doctrine. And Alba's regime of terror was based upon "gossip" or denunciation. The proverbial expression "to shit at the gallows" means that someone is unconcerned (cf. modern English "not to give a shit") about death and the authorities; "dancing under the gallows" was said of someone who either did not see danger or was not afraid of it.

Bruegel was thus presenting his picture of man and simultaneously commenting upon the political situation. His works certainly had no direct political effect, if for no other reason than the fact that they disappeared into private collections. It is by no means impossible, however, that they may have indirectly strengthened the Netherlands feeling of autonomy, thanks to his painting scenes from the life of his countrymen rather than from the world of classical mythology, and to his emphasizing the earthly element in man and his close attachment to Nature, instead of idealizing him in accordance with the Mediterranean concept.

The Parable of the Blind, 1568
It was only later that Bruegel's pictures received their titles; they have since undergone change in the course of the centuries, most of the works being known today under a number of names. That given this work – which is also known as *The Fall of the Blind* – refers to Christ's parable concerning the Pharisees (Matthew 15:14): "And if the blind lead the blind, both shall fall into the ditch." (Details p. 80)

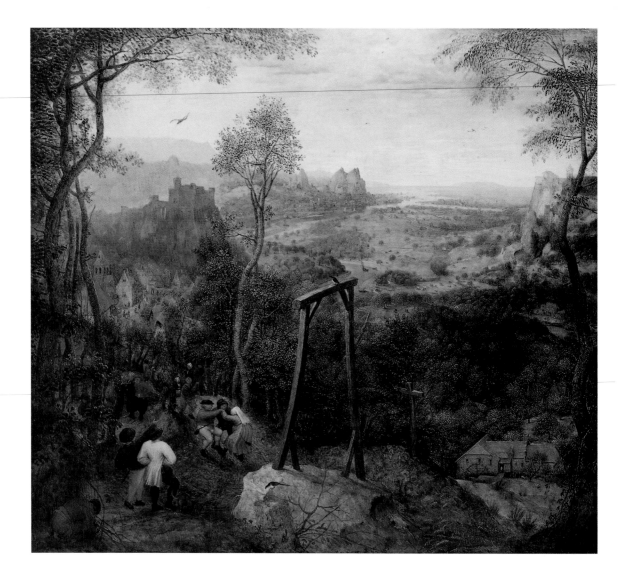

The Magpie on the Gallows, 1568

Following his customary practice, Bruegel painted a further landscape
view in the year before his death. He depicted a plain with fertile
meadows and fields, people cheerfully dancing, and a village lying con-
cealed in the shadow of a clifftop castle. The painting conveys the im-
pression of harmony and peace, disturbed only by the gallows in the
centre. Unlike death by the sword, death on the gallows was considered
dishonourable. And yet a man at bottom left is acting according to the
proverb "to shit at the gallows", meaning that he is not concerned about
death and the authorities, while "dancing under the gallows" was em-
ployed to describe someone who either did not see danger or was not
afraid of it. (Detail p. 83)

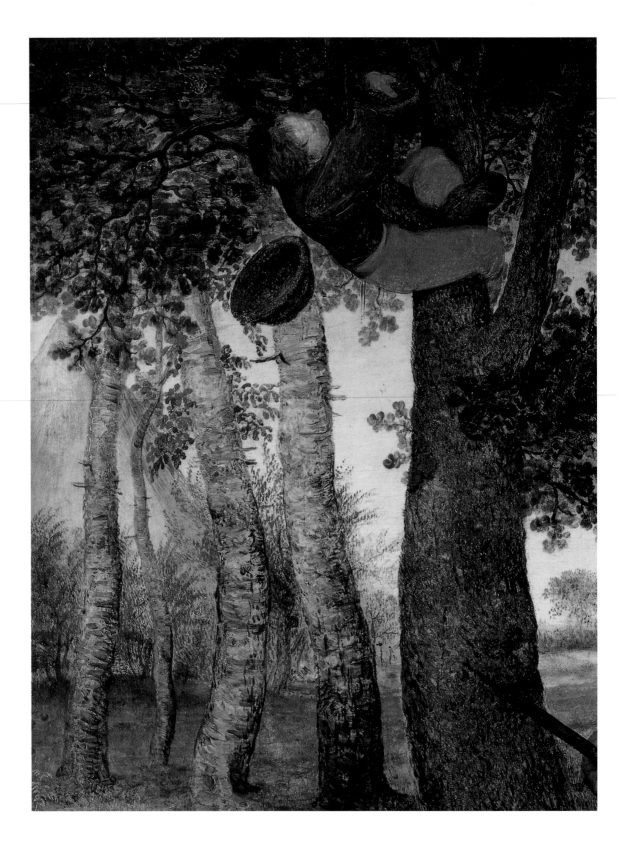

Pieter the Droll?

Almost all the 45 or so paintings experts now attribute to Pieter Bruegel the Elder were executed in the 12 years between 1556 and 1568. Bruegel was a good 40 years old when he died; it is impossible to say what else he would have painted, what further development his art would have undergone...

Many of his later pictures reveal his growing interest in single figures. Where we previously saw a multitude of small forms embedded in an expansive landscape, we now encounter individual large-scale figures, to whom the background is subordinated. One such picture is *The Parable of the Blind* (ill. p. 81); another is *The Peasant and the Birdnester* (1568, ill. p. 87). Bruegel has depicted a boy hanging from a branch while engaged in the attempt to steal the eggs from a bird's-nest, and a peasant pointing to the boy. The painting illustrates a proverb challenging one to take action: "He who knows where the nest is, knows it; he who takes it, has it." It is not the active person, the man of deeds, whom Bruegel has placed in the foreground, however, but the pensive man, perhaps rather unworldly, who, looking upwards into the distance, has not noticed that he is about to fall forwards into the water. Bruegel has painted him three times as large as the birdnester and placed him along the vertical middle axis, thereby giving him so much significance that he dominates the picture. Furthermore, by positioning him almost on the lower border of the picture, he has moved him into a position of direct proximity to the observer. The clumsy body has acquired additional weight through the artist's painting it in a blocklike manner. This huge figure with a curious expression on his face almost seems to be tumbling out of the picture towards the observer.

Yet the proverb of the birdnester will have served Bruegel at most as an incentive; he was primarily preoccupied with something quite different, namely the artistic problem of depicting a human body about to lose its balance. He had already shown considerable interest in the act of falling in *The Parable of the Blind* , portraying it in six phases seen from side-on. In *The Peasant and the Birdnester*, he depicts the initial stage of the fall head-on, adding to the forwards movement by means of the arm crooked backwards over the man's shoulder and thus – if we include the man's gaze – combining three directions in one single body: forwards, backwards, upwards. Everything else in the picture is necessarily subordinated to such a dynamic central field. Bruegel has kept the landscape flat; the eye can relax on the thatch-covered roofs of the houses in the background.

Other artists, mainly south of the Alps, were also working on the portrayal of complicated movements by this time; they had broken away from the rather static Renaissance standards of beauty and are commonly described as Mannerists. However, their great gestures, their floating, twisted figures, were still beautiful or spiritualized forms. Despite shared interests with Bruegel, the difference between their work and his is unmistakable.

The late works with large-scale figures include *The Cripples* (1568, ill. p. 91) and *The Misanthrope* (1568, ill. p. 86). An old man in a dark habit, whose purse is being

David Vinckeboons:
Allegory of Robbery (detail), undated
Vinckeboons (1576 – after 1632) has done a variation upon the theme of robbing a nest which Bruegel treated in one of his later paintings: instead of one spectator, there are two here, one of whom is also being robbed.

ILLUSTRATION PAGE 84:
The Peasant and the Birdnester (detail), 1568
This painting was probably inspired by a proverb distinguishing between active and passive people: "He who knows where the nest is, knows it; he who takes it, has it." The detail shows the nest robber, the active person; boldly and without a moment's hesitation, he has climbed up the tree.

stolen by a ragged figure in a glass globe, feels himself hard done by and deceived. At the bottom are the words: "Since the world is so unfaithful, I am in mourning." Thorns lie in his way; he is about to tread on them. Bruegel leaves the question open as to whether we are looking here at someone pursued by misfortune or at a wealthy man who favours the outward appearance of an unfortunate.

It may well be that the painter's contemporaries laughed amusedly over such a deceiver deceived or over the birdnester and the sky-gazer. At any rate, van Mander comments that Bruegel painted many "humorous scenes", and that this led to his being nicknamed "Pieter the Droll" by a considerable number of people. Van Mander continues: "There are few works by his hand which the observer can look upon and thereby keep a straight face…"[17] A straight face in the case of only a few works? Van Mander is presumably referring primarily to the pictures of peasants, for the peasant was fundamentally presented in contemporary literature and on stage as a stupid figure, uneducated, clumsy, quick to resort to violence – in short, a figure causing amusement. Those observers with this cliché, of the peasant in their heads and with no eye for the serious side of Bruegel's portrayals will perhaps indeed have found something "droll" about the dancing, eating, working countryfolk, their tendency to dress, attend to their appearance, and move in a different way to that customary in urban circles.

As well as this one public, prone to laughter, there was another, however, one represented by Bruegel's friend Abraham Ortelius, the famous geographer. Ortelius wrote that Bruegel had "painted much that simply could not be painted. All of the works by our Bruegel always imply more than they depict." In formulating his opinion in this way, Ortelius was presumably referring to Stoic thought as it may be identified in Bruegel's work, the concept of a universe in which each person should

The Misanthrope, 1568
A ragged figure in a glass globe is cutting the purse strings of an old man wearing a dark habit. Under the picture are the words: "Since the world is so unfaithful, I am in mourning." The question remains open whether it is the world which is deceiving the old man or vice versa. A shepherd is watching over his flock in the background; he is not complaining but is content to accept his fate, as the Stoics recommend.

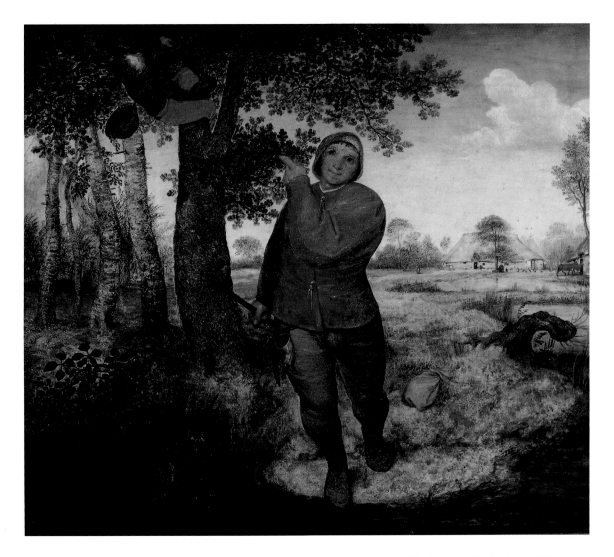

accept his predestined place. However, Ortelius equally praises Bruegel for having refrained from refining and prettifying people, expressing himself (translated from the Latin) as follows: "Those painters who, painting graceful creatures in the prime of life, seek to superimpose on the painted subject some further element of charm or elegance sprung from their free imagination disfigure the entire portrayed creation, are untrue to their model, and thereby deviate to an equal extent from true beauty. Our Bruegel is free from this fault."[18]

Storm at Sea (1568, ill. p. 88) is one of Bruegel's last paintings. It is unfinished and, like so many of his works, defies unambiguous interpretation. On the one hand, we see ships threatened by a storm – man not as master of Nature, in other words, but as its victim. On the other hand, the sailors have poured oil onto the water to calm the sea, and have sacrificed a barrel from their cargo to distract the mighty whale. Yet the barrel could be interpreted in a similar way to the nutshells in the picture of the Two Monkeys (ill. p. 23): in each case, animals – meaning man-kind – allow themselves to be distracted by something of little importance, instead of pursuing that which really matters. A comparison of this work with the earlier painting of a View of Naples (c. 1558, ill. p. 89), recalling Bruegel's journey to Italy,

The Peasant and the Birdnester, 1568
It is not the birdnester whom Bruegel has placed in the foreground but the pensive man, who, his head slightly raised, has not noticed that he is about to fall into the brook. Bruegel will presumably have been interested less in the proverb than in the body of the young man, who is on the point of losing his balance and will fall forwards. In *The Parable of the Blind*, from the same year, the artist presents the observer with a side-on view of the different stages of falling. (Detail p. 84)

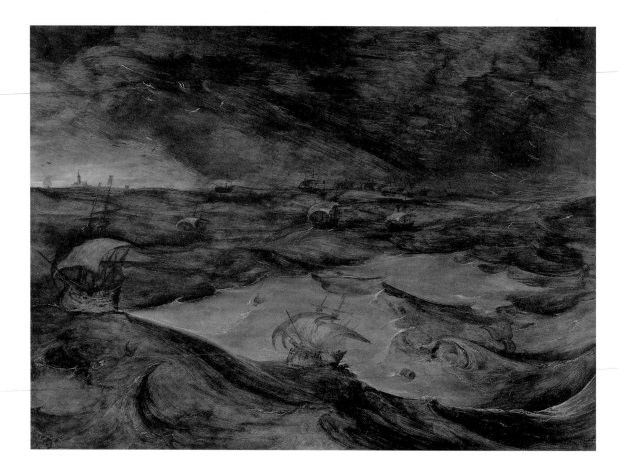

Storm at Sea, 1568
One of the vessels has poured oil overboard in order to calm the sea; another has thrown a barrel over the side in hopes of distracting a gigantic whale. Both attempts by the crews to save themselves appear in vain in the light of the waves and clouds: man is powerless compared with the forces of nature.

underlines the overpowering manner in which he has depicted the sea and the force of Nature here.

Bruegel's pictures were forgotten in the centuries following his death; they did not accord with the aesthetic rules, shaped as they were by the admiration of heroes, saints and potentates, by a bourgeois cast of mind or a view of Nature such as transformed it into a romantic vision. It was not until the present century that interest in him was rekindled; nowadays, the rooms devoted to his works in the Kunsthistorisches Museum in Vienna and the Musées royaux in Brussels are among the principal attractions for all art-lovers.

That this painter and his works should once again have been made accessible to the public stems initially from artistic innovations such as rendered invalid the conventional manner of looking at a picture. The Impressionists transformed faces and landscapes into dots of colour, while the Expressionists and Cubists "deformed" the human form. Startled and ultimately re-educated by contemporary painters, the observer became open once again to Bruegel's clumsy figures with their earthy colours and closeness to Nature, and even to the maimed bodies of *The Cripples* (1568, ill. p.91).

Cripples and blind people were a common sight in the artist's day, found begging along the roadside; accordingly, the fact that Bruegel included them in 1559 among the multitude thronging the market place in his picture *The Fight between Carnival and Lent* (ill. p.51; detail p.90) would not have given rise to comment. In 1568, however, the year in which he probably executed his last works, he isolated them, banish-

BOTTOM:
View of Naples, c. 1558
A comparison of *Storm at Sea* from 1568 with
a commemorative picture of a journey to
Italy, painted roughly a decade earlier, clearly
reveals the extent to which Bruegel's artistic
interests had meanwhile developed. Even if a
sea battle is raging before Naples, the exten-
sive landscape and the protective circle of the
harbour communicate a sense of order and se-
curity. (Detail top)

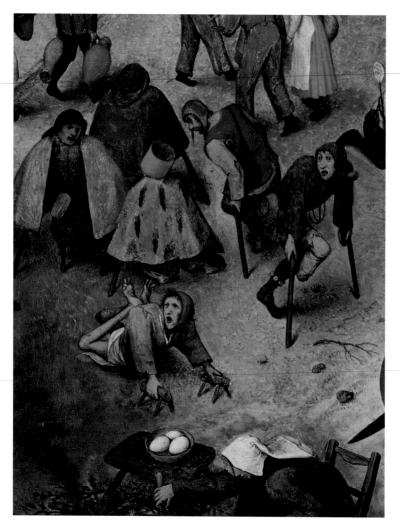

The Fight between Carnival and Lent
(detail), 1559
Cripples were a part of everyday life in villages and towns. Bruegel has incorporated them as if for granted in the great company of churchgoers and men, women and children dressed in carnival costumes. (Ill. p. 51)

ing them to a site surrounded by walls, moving them towards the observer and thereby rendering them in close-up. They are in fancy dress; their various items of headwear could represent the different social groups, with the mitre referring to the clergy, the crown to the aristocracy, the fur hat to the bourgeoisie, the paper helmet to the soldiery, and the cap to the peasantry. According to a Netherlands proverb, a lie goes like a cripple on crutches, meaning that everyone, whatever his station in society, is equally hypocritical.

Such an interpretation, while making sense, seems somewhat weak in the face of the gravity exhibited by this picture. It is because of Bruegel's vision that the present-day observer finds it interesting. The artist sees the people not in God's image but as imperfect beings, the dust of the ground from which they were created characterizing them more than the divine breath which was breathed into it. Bruegel is demonstrating even more clearly than usual that the difference between man and animal is by no means as great as one might think. In taking the cripples' legs, he has stripped them of their means of walking upright.

This has nothing to do with resignation; indeed, it seems more of a matter-of-fact observation. Nor is there any sense of sympathy; evidently this was relatively un-

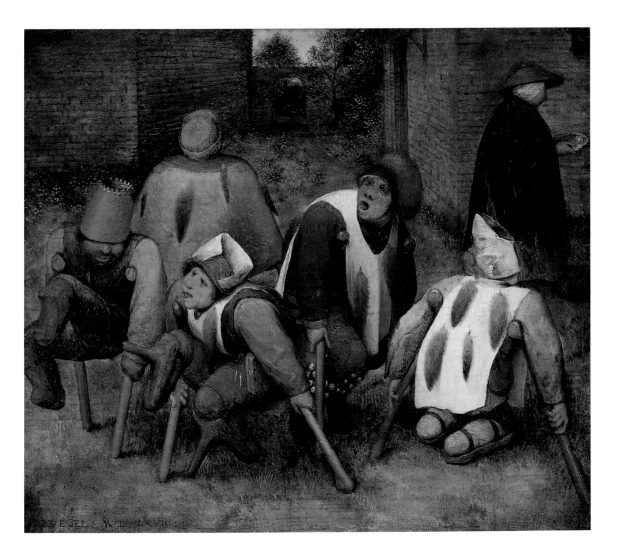

common in the 16th century, there being simply too many beggars in the streets and in front of the churches. And anyway, Bruegel's concern was not so much with the beggars as such, of course, as with beggars as representatives, whether of social groups or of a specific conception of man.

Bruegel's conception of man is more familiar to us than it could ever have been for an 19th-century museum visitor, for example. This is the consequence not only of the artistic innovations during the intervening years but also of the various major wars and ideological conflicts: they have rendered us sceptical towards every attempt to paint a more prettified and refined portrait of man than that to which he is in fact entitled.

Yet there is also something else here. Bruegel saw man as a product of nature, from which he draws his vital energy. We live today in an era in which nature is being progressively destroyed; Bruegel's paintings, especially the large landscapes, remind us of what we are losing. We see him not as Peasant Bruegel but rather as Eco-Bruegel. Such labels are unduly restrictive, of course; nonetheless, they serve to demonstrate what aspects of a great work are of particular relevance at a given time.

The Cripples, 1568
Bruegel depicts the cripples in isolation in this late picture. A woman is withdrawing, presumably having brought them food. The cripples appear excited; we cannot detect why. The different headwear could indicate the various social stations: mitre (clergy), fur hat (citizen), cap (peasant), helmet (soldier), crown (aristocrat). "A lie goes like a cripple on crutches," says a Netherlands proverb. This would mean that all of society is hypocritical. It is not this allegory which is of interest to us today, however, but rather Bruegel's view of maimed people.

Pieter Bruegel c. 1525–1569:
Life and Work

Landscape with the Parable of the Sower, 1557
In painting the peasant in the left-hand foreground, Bruegel was presumably thinking of the Parable of the Sower, who sows his seed on good soil and bad ground (Matthew 13).

Landscape with Ships and City in Flames, c. 1552–1553

1525 Pieter Bruegel's year of birth is unknown; it presumably lay somewhere between 1525 and 1530. Nor do we know where he was born, but it was probably in Breda, in the north of Brabant.

1527 Birth of Philip II of Habsburg, son of Emperor Charles V, to whose family belong not only Spain but also the Netherlands.

1528 Death of Albrecht Dürer; birth of Paolo Caliari, known as Veronese.

1540 Michelangelo paints *The Last Judgement* in Rome. Gerhard Mercator, the most important Netherlands cartographer along with Abraham Ortelius (later Bruegel's friend), publishes his "Globus Terrae".

1545 Bruegel probably studies under Pieter Coeck van Aelst in Antwerp, until 1550.

1550 Bruegel at work on a (lost) altar for the Mecheln glovers' guild.

1551 "Peeter Brueghels" is accepted as a master into the Antwerp artists' guild, the Guild of St. Luke.

1552 (or 1551) Bruegel travels via Lyons to Italy, returning over the Swiss Alps. While in Rome, he is believed to have worked together with Giulio Clovio, the miniaturist.

1556 Bruegel produces drawings in Antwerp for Hieronymus Cock's printing shop, "The Four Winds". Among works of his to be printed there are *The Big Fish Eating the Little Fish* and *The Ass in the School*.

1557 A series of seven engravings with the *Deadly Sins* follows.

1559 A series of seven engravings with the *Virtues* appears. The painter changes the way he spells his name, signing himself no longer Brueghel but Bruegel. He paints *The Fight between Carnival and Lent*.
King Philip II of Spain, successor since 1556 of Charles V, leaves the Netherlands, where he has been dwelling for some considerable time, never to return. He makes Madrid his seat of government. Margaret of Parma, his half-sister, is appointed Regent of the Netherlands. The Netherlanders demand the removal of Spanish troops.

1560 The dissection of corpses, previously forbidden by the Church, is henceforth permitted for research purposes.

1562 Bruegel paints *The Fall of the Rebel Angels*, *The Suicide of Saul* and *Two Monkeys*, among other works. He probably travels to Amsterdam, and thereafter settles in Brussels.

Landscape with the Flight into Egypt, 1563
As is the case with many of his paintings, Bruegel has treated the biblical motif here as if it were merely of minor importance.

Christ on the Sea of Tiberias, 1553

1563 The wedding takes place in the Brussels Church of Notre-Dame de la Chapelle between "Peeter brùgel" and "Mayken cocks", the latter the daughter of the painter's former teacher, Pieter Coeck.
The Netherlands refuse to pay King Philip higher taxes.

1564 Birth of his son Pieter (later known as "Hell" Bruegel)

1565 The paintings of the months or seasons are executed.

1566 The Antwerp merchant Nicolas Jonghelinck hands over 39 paintings to the city as surety; 16 of the works are by Bruegel (*The Tower of Babel*, *The Procession to Calvary* and *The Twelve Months*.)
Religious fanatics, carrying out the so-called "breaking of the images", plunder churches and monasteries.

1567 King Philip II despatches Duke Alba with 60,000 soldiers. Margaret of Parma resigns as Regent. Alba's "Council of Troubles" sentences 8,000 Netherlands "rabble-rousers" to death; Counts Egmont and Hoorne are arrested.

1568 Birth of the artist's second son, Jan (later known as "Velvet" Bruegel). Bruegel paints *The Parable of the Blind*, *The Magpie on the Gallows*, *The Misanthrope*, *The Peasant and the Birdnester*, *The Cripples* and *Storm at Sea*.
Egmont and Hoorne are executed.

1569 Pieter Bruegel dies, supposedly on 5 December. He is buried in the Church of Notre-Dame de la Chapelle in Brussels.
Open rebellion by the Netherlanders against Spain.

1604 Carel van Mander publishes *Het Schilderboeck*, a description of various artists and their works, among which are those by Pieter Bruegel the Elder.

The Temptation of St. Antony, 1557
This early painting is in the fantastic tradition of Hieronymus Bosch.

List of Plates

71 bottom
Summer, 1568
Pen and Indian ink, 22 x 28.6 cm
Hamburg, Hamburger Kunsthalle

72 top left
Paolo Veronese:
The Wedding at Cana (detail), 1562/63
Oil painting, 666 x 990 cm
Paris, Musée du Louvre

73
The Peasant Wedding Banquet, 1568
Oil on canvas, 114 x 164 cm
Vienna, Kunsthistorisches Museum Wien

75
The Land of Cockaigne, 1567
Oil on oak panel, 52 x 78 cm
Munich, Alte Pinakothek

76/77
The Wedding Dance in the Open Air, 1566
Oil on panel, 119 x 157 cm
Detroit (MI), The Detroit Institute of Arts, City of
Detroit Purchase

78
Pieter Bruegel the Younger:
Peasant Wedding Dance, 1607
Brussels, Musées royaux des Beaux-Arts de
Belgique

79
The Peasant Dance, 1568
Oil on oak panel, 114 x 164 cm
Vienna, Kunsthistorisches Museum Wien

81
The Parable of the Blind, 1568
Oil on canvas, 86 x 156 cm
Naples, Museo Nazionale di Capodimonte

82
The Magpie on the Gallows, 1568
Oil on oak panel, 45.9 x 50.8 cm
Darmstadt, Hessisches Landesmuseum

85
David Vinckeboons/Vinckebooms:
Allegory of Robbery (detail), undated
Pen and bistre with wash, 29.5 x 39.7 cm

86
The Misanthrope, 1568
Tempera on canvas, 86 x 85 cm
Naples, Museo Nazionale di Capodimonte

87
The Peasant and the Birdnester, 1568
Wood panel, 59 x 68 cm
Vienna, Kunsthistorisches Museum Wien

88
Storm at Sea, 1568
Oil on panel, 71 x 97 cm
Vienna, Kunsthistorisches Museum Wien

89
View of Naples, c. 1558
Oil painting, 39.8 x 69.5 cm
Rome, Galleria Doria Pamphilj

91
The Cripples, 1568
Oil painting, 18 x 21.5 cm
Paris, Musée du Louvre

92
Landscape with the Parable of the Sower, 1557
Oil on panel, 702 x 102 cm
San Diego (CA), Timken Art Gallery

93 top
Landscape with the Flight into Egypt, 1563
Oil on canvas, 37.2 x 55.5 cm
London, Courtauld Institute Galleries

93 bottom
The Temptation of St. Antony, 1557
Oil on canvas, 58.5 x 85.7 cm
Washington (DC), © 1993 National Gallery of Art, Samuel
H. Kress Collection

The publishers would like to thank the following museums
and collectors for making available copies of the works on
the pages listed below:
Scala, Antella: 64, 86
Archiv für Kunst und Geschichte, Berlin: 12, 21, 35, 51,
67, 77, 81, 92
Jörg P. Anders, Berlin: 23, 33, 71
Elke Walford, Hamburg: 71
Bridgeman Art Library, London: 52
© National Trust 1991 Photographic Library/Angelo
Hornak, London: 28
© Photo R.M.N., Paris: 72, 90
Artothek, Peissenberg: 29, 32, 44, 48, 57, 61, 70, 75, 88
Photography by Araldo De Luca, Rome: 89
Giraudon, Vanves: 64
Studio Milar, Vienna: 58

Rose-Marie Hagen, born in Switzerland, studied history
and Romance languages and literature at Lausanne, submit-
ting a dissertation on Proust for her "Licence ès Lettres".
She has spent study visits in Paris and Florence, and has
taught at grammar-school level in Lausanne as well as at
the American University, Washington (DC).

Rainer Hagen, born in Hamburg in 1928, studied literature
and drama in Munich. He was awarded a doctorate for his
thesis on *Das politische Theater in Deutschland zwischen
1918 und 1933* (Political Theatre in Germany between
1918 and 1933). He worked for North German Radio in
the 3rd Channel (state regional television) from 1956 to
1989.

The two have collaborated on the following: 15 films for
television in the series "Geschichte in Bildern" (History in
Pictures); more than 100 issues in the series "Bilderbefra-
gung" (Questions on Pictures) for *art* magazine. Books:
Kinder wie sie im Buche stehen (Children as Portrayed in
Books, 1967); *Warum trägt die Göttin einen Landsknechts-
hut?* (Why Is the Goddess Wearing a Lansquenet's Hat?,
1984); *Bildbefragungen* (What Great Paintings Say) 1993,
Benedikt Taschen; to be published in English in 1995).

Notes

1 Cf. synoptic survey for the year 1565, in: Bob Claessens
and Jeanne Rousseau: *Unser Bruegel* (Our Bruegel). Ant-
werp 1969
2 Marcus van Vaernewijck, quotation from M. Seidel/R.H.
Marijnissen: *Bruegel*. Stuttgart 1984, p. 268
3 Carel van Mander: *Das Leben der niederländischen und
deutschen Maler* (The Lives of Netherlands and German
Painters) from 1400 to c. 1615. Quotation taken from the
1617 edition with commentary by Hanns Floerke. Worms
1991, p. 156
4 Claessens/Rousseau, p. 48
5 Quotation from Ernst Günther Grimme: *Pieter Bruegel,
Leben und Werk* (Pieter Bruegel, Life and Work). Cologne
1973, p. 105, illus. p. 82
6 Henri Pirenne: *Geschichte Belgiens* (History of Bel-
gium), vol. 3. Gotha 1907, p. 564
7 The Habsburg statesman Antoine Perrenot de Granvelle
(or Granvella), 1517–1586, owned two early paintings by
Bruegel, namely *View of Naples* and *Landscape with the
Flight into Egypt*, which he could have acquired during his
time in the Netherlands. Cf. among others Philippe Robert-
Jones: *Bruegel, le peintre et son monde* (Bruegel, the
Painter and his World). Brussels 1969, p. 48 and 60
8 John Calvin: *Institutio Religionis Christianae*, Book 1,
Chapter 11.
9 Among those authors attributing a moralizing tendency
to *Winter Landscape with a Bird-trap* are Seidel/Ma-
rijnissen, p. 49, and Wolfgang Stechow: *Bruegel the Elder*,
New York 1990, p. 98. For the opposite view, see Alexan-
der Wied, London 1980, p. 125: "No convincing evidence
for this theory has been produced."
10 Van Mander/Floerke, p. 154
11 Pieter the Younger, c. 1564–1638, known as "Hell"
Bruegel; Jan the Elder, 1568–1625, known as "Flower" or
"Velvet" Bruegel
12 "For what should seem so great about human things to
him who is familiar with the entire eternity and size of the
whole world." Cicero, *Tusculanae disputationes*, quotation
from Justus Müller Hofstede: "Zur Interpretation von Brue-
gels Landschaft" (On Interpreting Bruegel's Landscape),
in: *Pieter Bruegel und seine Welt* (Pieter Bruegel and His
World), eds. Otto von Simson and Matthias Winner, Berlin
1979, p. 131. "The horse was…", Cicero, *De natura deo-
rum*, Müller Hofstede, p. 133
13 From the *Album Amicorum*, which Ortelius wrote in
Latin somewhere around 1573, quotation from
Claessens/Rousseau, p. 176
14 There are two versions of this painting, both of them in
Brussels. One may be found in the Van Buuren Collection,
the other in the Musées royaux des Beaux-Arts. They dif-
fer only slightly from each other; perhaps it is a question
here of two copies of an original meanwhile lost to us
15 Ovid: *Metamorphoses*, Book 8, line 220
16 Vasari on Michelangelo, quotation from Michael Jäger:
Die Theorie des Schönen in der italienischen Renaissance
(The Theory of the Beautiful in the Italian Renaissance),
Cologne 1990, p. 245
17 Van Mander/Floerke, p. 154
18 Claessens/Rousseau, p. 176
All quotations have been translated from the German ori-
ginal for this edition.